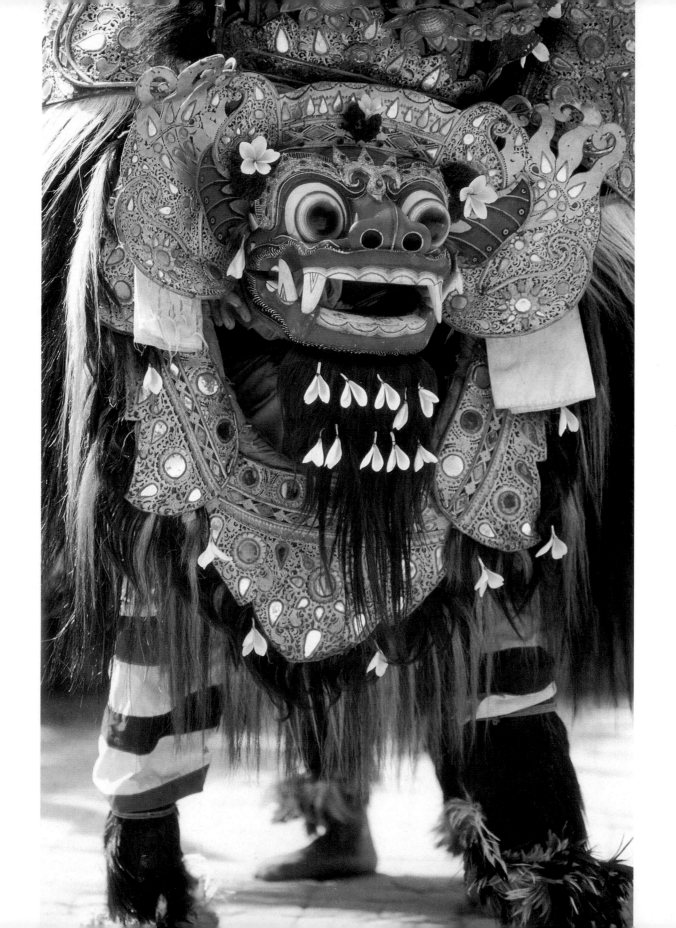

SPIRITS OF AN ANCIENT DRAMA

Judy Slattum

PHOTOGRAPHS BY
Paul Schraub

PREFACE BY
Hildred Geertz

CHRONICLE BOOKS • SAN FRANCISCO

Printed in Hong Kong.

Library of Congress Cataloging in Publication Data

Slattum, Judy.
 Masks of Bali/Judy Slattum; photographs by
Paul Schraub.
 p. cm.
 Includes bibliographical references (pp.126–127)
 ISBN 0-8118-0240-X (hc).—ISBN 0-8118-0062-8 (pb)
 1. Masks—Social aspects—Indonesia—Bali (Province)
2. Masks—Indonesia—Bali (Province)—Religious aspects.
3. Rites and ceremonies—Indonesia—Bali (Province) 4. Bali
(Indonesia: Province)—Religious life and customs. 5. Bali
(Indonesia: Province)—Social life and customs.
I. Schraub, Paul. II. Title.
GT1748.I52B37 1992
391'. 434'095986—dc20 92-2569
 CIP

Facing title page: Barong Ket

Editing: Judith Dunham
Book and cover design: Robin Weiss
Linotronic Output: On Line Typography
Cover Photograph: Paul Schraub

Distributed in Canada by Raincoast Books,
112 East Third Avenue, Vancouver, B.C. V5T 1C8

10 9 8 7 6 5 4 3 2 1

Chronicle Books
275 Fifth Street
San Francisco, CA 94103

For Surya,
my guide to the hidden Bali.

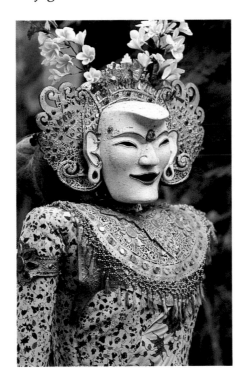

ACKNOWLEDGMENTS

I gratefully acknowledge the following individuals and institutions, without whom this book would not have been possible: my sponsor in Bali, Cokorda Agung Mas and the Mudraswara Foundation; the Indonesian Institute of Sciences (Lembaga Ilmu Pengetahuan Indonesia) for a research permit and special visa; the Directors of the Art Centre and Museum Bali for permission to photograph their mask collections; and the staff of Gedong Kirtya, Singaraja, for assistance in finding and translating *lontar*.

I also thank the following Balinese scholars, carvers, and musicians, who supplied the bulk of the information in this book through interviews they graciously granted: in Tampaksiring—dancer and costume maker I Wayan Tempo; in Singapadu—carver I Wayan Tangguh, carver I Wayan Juala, dancer and carver Cok. Raka Pisnu, carver, dancer, *dalang*, and musician I Gusti Gede Raka, teacher I Gusti Ngurah Wirasama; in Mas—carver and *dalang* Ida Bagus Griya, carver, dancer, *dalang* and musician Ida Bagus Anom, carver, dancer, and priest Ida Bagus Sutarja, carver and dancer Ida Bagus Ambara; in Batuan—dancer I Ketut Kantor, dancer I Made Jimat, dancer and painter I Wayan Sudana, and singer I Wayan Regeg; in Denpasar—Instructor I Gusti Bagus Nyoman Pandji, Instructor I Gusti Agung Ngurah Supartha; in Batubulan—dancer I Gusti Ngurah Agung, mask maker Regug, and dancer I Wayan Bretong; in Blahbatuh—I Gusti Ngurah Bagus; and in Sanur—Anak Agung Alit and Anak Agung Kompiang Delung.

Further, I am indebted to I Nyoman Suradnya and I Made Suryasa for accompanying me on interviews, working as translators, and correcting my work; to Dr. Andrew Toth, Dr. Hildred Geertz, and I Made Bandem, M.A., for correcting my informational accuracy and offering advice; and to Virginia Lee, Jane Ryan, Nick Roberts, Karen Mazik, Will Roblin, and Ann Steward for proofreading and editing. Special thanks to Leonard Pitt for introducing me to Bali through its masks; to Jim and Jean Houston for help in finding my publisher, and to Jay Schaefer, my editor, for making this book a reality.

TABLE OF CONTENTS

PREFACE

asks are only fragments of costumes, just as masked dancers are only a few of the participants in Balinese rituals, and the dances themselves only certain steps among the many that make up Balinese worship. For Westerners, masks are, in themselves, objects of fascination and pleasure. They may serve to epitomize, for visitors to Bali, something about their experiences. For the Balinese, the meanings of masks are much deeper. These masks, and this book about them, are wonderful entry points into a greater understanding of much that is important to the Balinese.

Masks, for Balinese, may serve as lightning rods, to collect, momentarily, a portion of the cosmic energy, the vital life of the universe. Other kinds of material objects are used to harness the invisible forces, such as small doll-like figures, bowls of water, incense, and even people—when they go into what Westerners call "trance" and what they call "being entered." A Balinese ritual is an invitation to those forces to "come down" and listen to human requests for their protection and forbearance. While present in this world, these energies have no material form in themselves and must take up residence in vessels provided them. And while here, they are entertained by feasting, music, and dance.

Balinese today stress that their religion is monotheistic, but that their God takes as many forms as the sun has rays. Each time the divine force visits the world, it comes as clouds of beings of all shapes and potencies, and it comes in different places at the same time. As monists, Balinese do not see sharp qualitative differences between spiritual and material, or supernatural and natural, or between God and humanity. Rather they stress the inadequacy of our human knowledge of those aspects of the universe that are normally intangible. Masks are seen as aids not only in visualizing divine powers but also in providing them momentary material manifestations.

The great many kinds of masks are well illustrated in this book. Each named type has a range of forms. No Rangda is exactly like any other, and each one has a different personal name. This great variety of masks, and the great variety of dance performances within which they appear, is proof that few doctrinal constraints are placed on the imaginations of the makers. It also strongly suggests that the masks have a history of change and development over the past thousand or more years during which Balinese have been making and dancing them.

Just as Western religions and arts have complex histories, so also do those of the rest of the world. The difference is only in the amount of evidence and documentation of those changes.

The language of religion is one of immutability and tradition, but the actuality of practice is often creativity and innovation. Balinese oral accounts credit an inspired individual carver with the making of the present form of the Barong Ket, the best known of the four-legged demon-beasts that parade around Bali's roads. The great tragicomic play, the Calonarang, whose protagonist is Rangda, goes back to a sixteenth century epic, but was given one of its present shapes in 1890 in the court of Gianyar. A reliable sense does not exist for the longer term changes in Balinese styles of worship or dramatic productions, as it does for the transformations of modern Western drama from the ancient Greek rituals or the medieval morality plays to the contemporary drama. Historical alteration and renovation, rather than indicating triviality, demonstrate the continuing great significance of the masked dances for the Balinese throughout the changing eras.

The dance rituals that employ these masks are intended as more than spectacles for audiences. For the most part, the masks are simply paraded around the village, and are brought into temple ceremonies so that the beings and powers temporarily residing in them may see their human supporters and meet other visiting beings. When those wearing masks or those attending to them are possessed, the Balinese take this as a powerful sign that the divine powers have indeed arrived. When they are not possessed, however, this is a sign that the spirits have chosen to stand aside and enjoy the performance itself.

Judy Slattum has organized this book in an attractive manner easily accessible to Westerners. But in encountering first the splendid Topeng play cycles with their wonderful portrayal of legends from Bali's courtly past, the reader might see the masks as merely visual aids to the plots. Yet the dance dramas, one of the glories of Balinese culture, are primarily narrative elaborations of meanings already inherent in the masks. The Balinese believe that the masks themselves provide inspiration for the dancers, "give the dancelife," as they say it. So, too, the story or plot, music, characterization, and staging all come from the masks. Providing a dramatic frame for the display of the masks is, in Balinese terms, giving the masks—and their vivifying beings—a chance to "speak" and to "move around," as well as a chance for the masks' human servants to entertain them. The masks are, indeed, members of their own village communities.

Hildred Geertz
Princeton, New Jersey

INTRODUCTION:

THE LIVING MASKS OF BALI

Mask performances have been important rituals on the Indonesian island of Bali for over one thousand years. Although many ancient societies used masks to celebrate their religions, Bali is one of the few places where the ritual art has never disappeared and is, in fact, thriving. Carvers are producing more beautiful and elaborate masks than ever, and thousands of people worldwide collect these compelling objects. The proliferation of artists and performance groups indicates that the tiny island is undergoing a cultural renaissance, the centerpiece of which is the *tapel*—the beautiful Balinese mask.

A mask is used to create more than the character in a drama. The powerful lines of the mask catch the light with greater impact than the human face alone can convey, and the stability of the mask's features has an intensity stronger than that of a human expression. Worn in a performance accompanied by Balinese gamelan music, the mask becomes the catalyst for the rhythms and movements of the performers. The piercing eyes look outward, yet also seek to reveal the social archetypes behind the drama, for the principal characters and their allies are defined morally to illuminate the ethics of human relationships.

Balinese masks take a broad range of sculptural forms. Although masks are almost always carved from wood, mask makers create a textural spectacle by using a variety of materials: boar's teeth, horsehair, jewels, gold leaf, Chinese coins, buffalo hide, rabbit pelts, and mirrors. The striking glossy surface is achieved by endless sanding and at least forty coats of paint. The expressive tautness of a mask's features, the hallmark Balinese style, is inseparable from the posture and movement of the dancer.

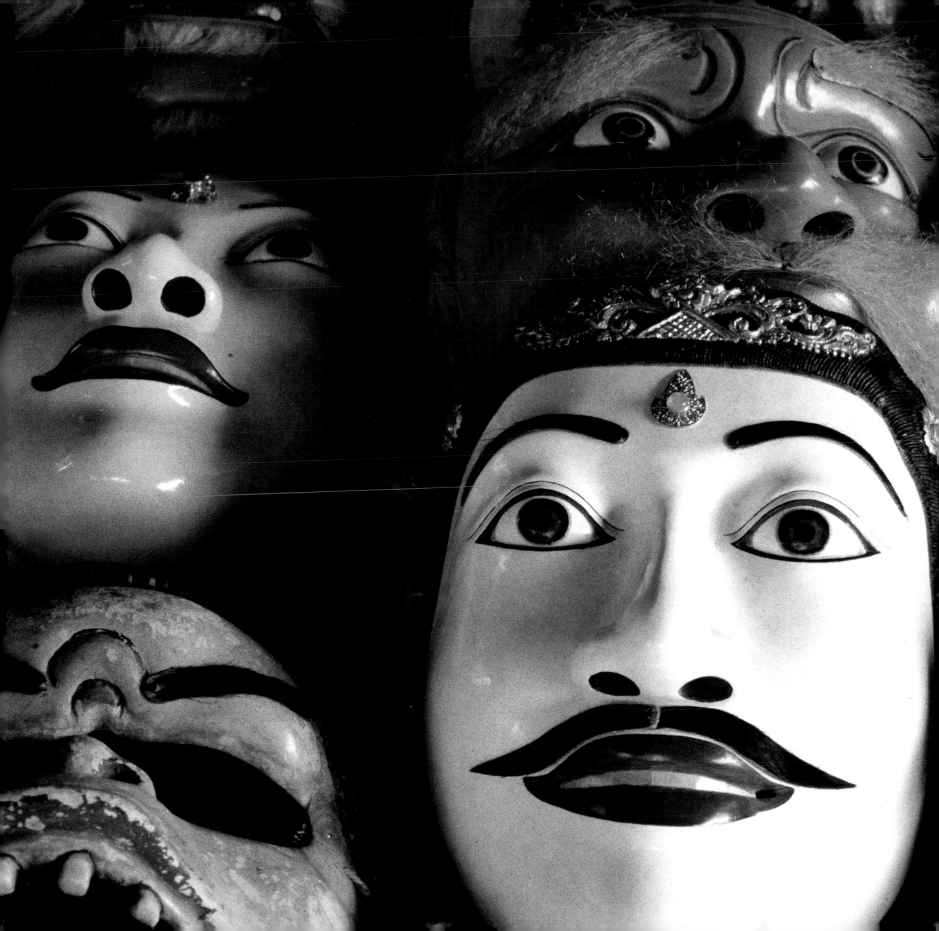

DRAMAS Masks are used in four traditional Balinese dramas and processions: the Topeng, which enacts stories from the times of the old Balinese kingdoms and establishes a link with the ancestor world; the Barong, which involves giant puppets and animals that serve as protective spirits enabling a village to ward off evil; the Wayang Wong, which performs the *Ramayana*, a great Hindu epic dramatizing the triumph of virtue over vice; and the Calonarang, which challenges local witches by appealing for the support and protection of Durga, the Queen of Witches and Goddess of Death. A chapter in this book is devoted to each of these dramas and a final chapter describes the mask-carving process.

of the dancers. The coarser a character is, the more the features are exaggerated: eyes bulge, mouths and noses thicken, and teeth are fangs. Color also reveals character.

Balinese masks and dramas have been influenced by other Asian cultures and reveal the relationships to the art forms of other countries. Older Balinese Topeng masks resemble traditional Javanese masks, whereas Barong Brutuk masks, from the aboriginal Balinese village of Trunyan, are similar to masks found on the Indonesian islands of Sulawesi and Sumatra. Demon masks bear a strong similarity to their counterparts in Nepal and Sri Lanka and to the Nagales masks of Central and South America. Balinese drama is similar in style to Italian commedia dell'arte, and the half masks of the Balinese comic characters are like traditional commedia masks. The animistic Barong masks resemble the old sacred animal masks worn during certain rituals by Bhutanese monks, and the most important mask in Bali, the Barong Ket, is believed to be based on the Chinese dragon.

Animal masks are mythological rather than realistic. Conscious of the distinction between humans and animals, the Balinese emphasize the difference by designing animal masks that seem closely related to demons, even for magically powerful and god-related animals like the heroic and delightful Hanuman, the white monkey of the *Ramayana* epic. Birds, cows, and even frogs have gaping mouths and horrendous protruding fangs. Protuberant eyes with wide black pupils stare from golden irises in masks that can hardly be called attractive, despite their elaborate crowns and fancy earrings.

Perhaps the most exciting masks are those of the witches and what are called low spirits. The low spirits, who can be troublesome if not appeased, are sometimes described by Westerners as demons. This is inaccurate, since low spirits also have the power to perform good deeds and provide protection. The Balinese do not separate the supernatural from the natural. The spirit world is a living force that must be recognized and appeased through rituals and offerings. Because the Balinese grant the masks powers that befit their roles in society, the masks of witches and low spirits are the largest

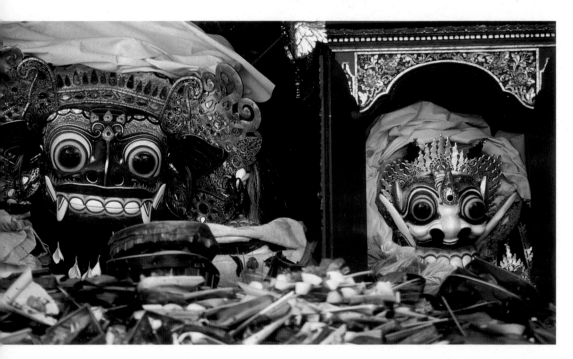

The three types of masks used in these dramas depict humans, animals, and demons. Human-looking masks can be full face or three-quarter face (extending to the upper lip), or can have a movable jaw. They are expected to resemble certain character types rather than specific people. Heroes and heroines are stereotypically handsome, with refined features matched by the movements

and most grotesque of all traditional masks. The imposing wigs on most of these masks magnify the head and stature of the wearer. A basket device attached inside the construction holds it to the wearer's head. Since the arrangement is relatively unstable, dancers often hold their unwieldy masks while they perform.

The Balinese classify the masks of heroes, clowns, and demons according to their qualities. The dashing heroes (often incarnations of gods), beautiful queens, and virtuous kings are described as *halus,* a Balinese word meaning "sweet," "gentle," and "refined." Demons, animals, and brutish types, including antagonist kings, are referred to as *kras,* or "strong," "rough," and "forceful." There are certain distinctions in between, which usually encompass the clowns and servants.

Possessing exaggerated expressions and dehumanized features, the clowns and rustics of Balinese drama, known as *bondres* characters, are at once grotesque, humorous, and intriguing. Portrayed as being of low caste, they manifest a plethora of deformities. Some theorists believe that the harelips, crossed eyes, hunchbacks, buck teeth, and other disfigurements mirror the genetic defects found among the people of Bali. To understand how the Balinese audience can find humor in the misery of deaf, blind, lisping, and otherwise afflicted people, it is important to keep in mind the Balinese custom of turning horror into humor and laughing at distress, in the same way we might laugh at the plight of certain unfortunate cartoon characters. Similarly, in the early twentieth century, Western vaudeville, minstrel, and variety shows sometimes exploited physical deformities, and even racial characteristics, for humor.

The favorite clowns in Balinese mask performances are two brothers who translate the archaic Sanskrit text of the traditional drama into Balinese vernacular spiced with bawdy dialogue and physical comedy. The brothers are called the Penasar, from *dasar,* the people who tell the root of the story or "the basic ones." The older is the hefty, pompous Penasar Kelihan; the younger is the smart-mouthed Penasar Cenikan. They move across the boundaries of time, from the ancient past to the present,

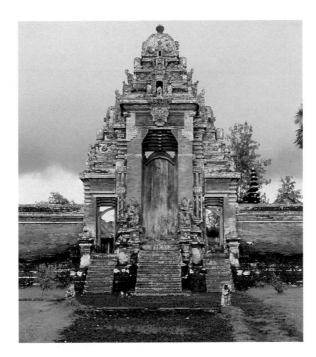

to convey the plot of the drama. The Penasar, who are said to represent common people and appear in most mask dramas, serve as attendants to the central characters. After their master enters the drama, the brothers are referred to as *parekan,* meaning servants to a high-caste person. As clowns, they have no social status and are free to travel between the world of the audience and the formalized drama on stage. In the tradition of all good fools, they act as social gadflies who gently lampoon human foibles.

RELIGION

There are at least twenty thousand temples in Bali, in addition to the family temples that the 2½ million Bali Hindus have in their homes. Each temple holds a birthday festival, or *odalan,* once every 210 days, the length of the Balinese calendar year. Festivals range from a simple affair in a family home to a lengthy celebration with many performances and offerings attended by worshippers from all over the island.

The Bali Hindu religion, the foundation of the ordered Balinese society, pervades every aspect of life. Bali Hinduism, which has roots in Indian

Hinduism, adopted the animistic traditions of the indigenes, who inhabited the island around the first millennium B.C. This influence strengthened the belief that the gods and goddesses are present in all things. Every element of nature, therefore, possesses its own power, which reflects the power of the gods. A rock, tree, dagger, or woven cloth is a potential home for spirits whose energy can be directed for good or evil. Masks are regarded as powerful receptacles for wandering spirits. A mask filled with divine energy becomes *tenget*. Made from a specific wood that is cut at specific times, *tenget* masks are generally associated with a certain number of rituals. However, even art shop masks, those made in an unconsecrated assembly-line manner to be sold to tourists, have been known to become possessed. A former director of Bali's Art Centre has a concise explanation: "If you make an attractive home, someone will want to live in it."

Masks in a *tenget* state may lose some of their special energy over time and need to be "recharged" in a special ceremony. Initiations of renewed or new masks, called *pasupati*, can involve as many as ten days of feasting, performances of dance and Wayang Kulit (shadow puppets), cockfights, and processions. A high priest is called to officiate the exact moment when the "body" of the mask (wood) separates from the "head" (spirit) and the god inhabiting the mask is "sent home." After the newly vitalized mask is returned to the temple, another set of ceremonies is held to invite the spirit back to the mask. The powerful mask of Durga, Goddess of Death and Queen of Witches, and sometimes called Rangda, is occasionally tested to see if its power is still burning. If explosions of fire come from the eyes, ears, head, nose, or mouth of the mask, it is considered *sakti* (sacred or powerful). It is placed in the village cemetery in the middle of the night during the new moon. This is an especially auspicious time called Kajeng Kliwon Pemelastali, a dangerous time when restless spirits are present and must be appeased with offerings.

Sacred masks are never displayed on walls as works of art are in Western homes, but are kept in simple fabric bags with drawstring tops. The color of the bag is important—whether yellow, white, or black-and-white checked—because color symbolism affects the spirit of the masks. Once encased in the bags, the masks are placed in baskets, which in turn are stored within the temple complex. If a mask belongs to an individual, it will probably be kept inside the family temple. Sacred masks are only displayed for their birthdays, which will be part of an *odalan*, or temple festival. Dancers unveil their masks when commissioned to perform at an *odalan*. Only rarely is a mask uncovered in order to be reconditioned: the paint refreshed, worm holes filled, and gold leaf touched up. This is never done casually, but in conjunction with elaborate rituals.

Masks made from the same tree are felt to have family ties. When a tree produces a knotlike growth, it is called *beling*, which means "pregnant." Care is taken not to damage the tree, and when the cut is made, a special ceremony is held to appease the spirits of the tree. If these rituals are not followed, a spiritually powerful tree could use its energy to cause destruction. In Singapadu village, home of two of Bali's most renowned carvers, wood is no longer taken from an especially *tenget* tree that grows at the edge of the village. Two priests performed the requisite ceremonies before removing wood, but within a week, both died of mysterious causes.

According to Bali Hinduism, for every positive principle or constructive force there is an equally powerful destructive force. These are sometimes referred to as forces of the right (high) and forces of the left (low). The two elements ideally coexist in balance so that neither assumes too much power. Maintaining this precarious equilibrium is a constant preoccupation for the Balinese, who prepare daily offerings to satiate the spirits and keep them under control.

Offerings, or *banten*, vary according to whether they are intended for a high or low spirit. They may consist of a combination of incense, flowers, old Chinese coins, fabric, betel nuts, *arak* (liquor), holy water, palm-leaf decorations, and food. The food is not actually meant to be eaten by the gods but functions as a means by which the people give

back what rightfully belongs to the spirits. The most significant moment in the life of the offering is its dedication. After that, what happens to it is unimportant. Consequently, offerings to low spirits, which are left on the ground, are usually scavenged by chickens or dogs. The larger offerings to high spirits are taken back to the family home after residing for a while at the temple, and the edible parts are then consumed by family members.

Balinese temples, embellished with a decorative display of stone carvings, consist of breezy, open-air courtyards, surrounded by a wall and entered through a large split gate elaborately carved with the fierce, fanged grimace of Bhoma, Son of the Earth, looming at the top. Outside the entrance is a freestanding wall. Beyond the wall is a large, open area with many small shrines of various sizes, each dedicated to a different god or goddess. At temple festivals, the normally somber temples are highly decorated, and people come to pray and dedicate their offerings, then retire to talk with friends. A festival is a highly social occasion, culminating in a live performance of mask dance or puppets presented for all to enjoy—local villagers and guests as well as the spirits of visiting deities and ancestors.

The dance and mask dramas that are performed at the temples as part of the *odalan* are considered important offerings to the gods and goddesses. The deities would be hesitant to attend any birthday celebration where there is no entertainment. A mask dancer makes an offering of his skill each time he performs, in some cases even serving in a capacity similar to a priest. Wali dances, those permitted to occur in the inner sanctum of the temple complex, are directed toward the deified ancestors, who are honored guests, and tend to be involved with spirits rather than plot.

In some parts of Bali, trance is a frequent part of a ritual; elsewhere, it is nonexistent. In Calonarang and Barong mask dramas, trance is common. The subject matter of these dramas is witchcraft, the supernatural, and the battle of positive and negative forces. The major characters, Durga, the Goddess of Death as Rangda, and Barong Ket, Lord of the Jungle, battle with every ounce of magical power they can harness.

Kerambitan in southwest Bali is one of the areas known for highly active spirits and the frequency of trance possession. A dancer who once worked as director of Bali's Art Centre tells a story about

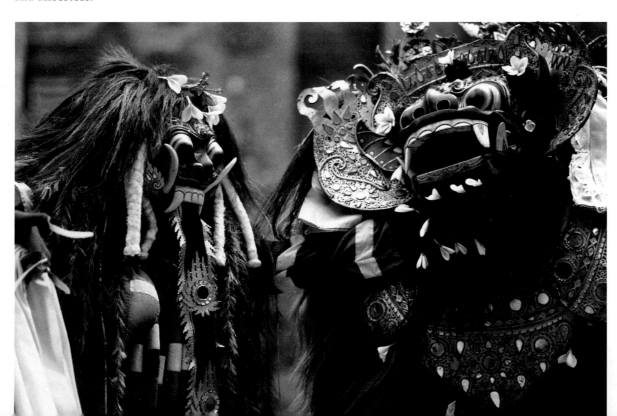

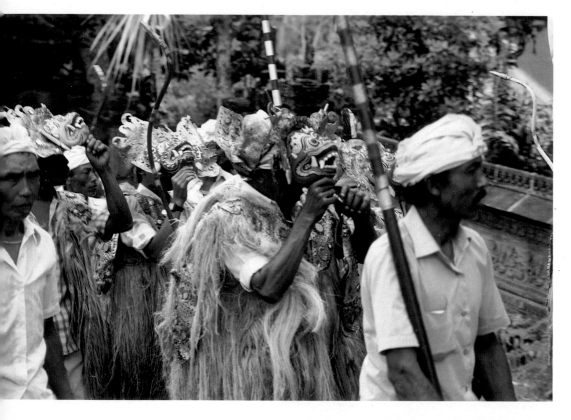

the Rangda and Barong masks of Kerambitan, his village: "Our priest had a dream that Rangda and Barong masks must be part of the village temple, so we had them created in the prescribed manner. Once they were brought to their temple home, they began fighting with each other while they were inside their baskets. They created so much noise and tension that the masks had to be separated." Although the Rangda mask was moved to another temple, the two masks still fought and the Rangda mask was moved to another village. On the masks' birthday, the day they were both consecrated, they had to be united in the temple again. Rangda was brought from the other village, displayed in the ceremony, and then immediately put away.

LANGUAGE
The Balinese inherited a caste system from ancient India which today bears little resemblance to the Indian caste structure. In Bali there are three high castes: Brahmana, the priest caste; Kasatria, the noble caste; and Wesia, the warrior caste. Within each are many subcastes. The low- caste Balinese, who make up the majority of the population, are called *sudra*, or *jaba*, which means "outside the palace." There are no untouchables. Until quite recently, the head of a high-caste person had to tower above people of lower castes. The exception was when people of mixed caste performed together, either as actors in a drama or musicians in a gamelan orchestra. Well-educated kings were expected to study dance or music, and when they performed, they had to sit on the ground with the rest of the musicians or portray a bowing, simpering servant to a king enacted by a low-caste performer.

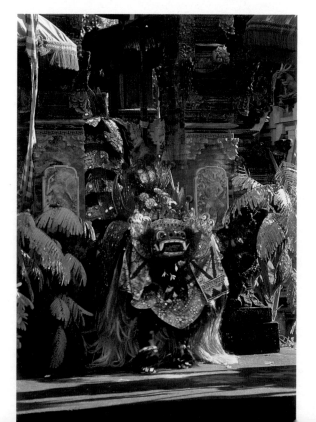

Balinese who are strangers discover each other's caste by inquiring as to the other person's position or by reading the clues in each Balinese given name. Then they slip into the language appropriate to their relationship, the higher caste of the two speaking the guttural, colloquial Balinese to the low-caste person, who responds with the more sweet-sounding Bahasa Halus, or high Balinese. The Balinese are highly conscious of time, place,

and situation, which are reflected in their many-layered language. Although a few traditionalists, especially of the high caste, hold on to the stricter aspects of caste, young people consider the caste system outmoded, and many, especially university students, abandon caste titles when identifying themselves and choose to converse in modern Indonesian, the official national language. Caste is quite significant in Balinese drama, which focuses on the old caste-conscious courts of the Gelgel dynasty (1550–1639) in central Bali.

The improvised dialogue of the mask drama covers a millennium of history and joins past and present by employing graceful poetry and impudent obscenity. At the most formal end of the language spectrum is Sanskrit, which is used for prayers. Old Javanese (or Kawi) and middle Javanese are also spoken in mask drama. Kawi is associated with the early Indian epics, the *Ramayana* and *Mahabharata*, which were translated for the Hindu Java court. The Javanese versions of these stories arrived in Bali in A.D. 994 and are still quoted as examples of ancestral prudence. Kawi texts are chanted in a low, quavering voice to salute the ancestor spirits during temple ceremonies and performances. Middle Javanese is a poetic but archaic language understood by very few Balinese. It was first used in the old Gambuh dramas that originated in Java and were presented in Balinese courts beginning about 1600. Modern Balinese audiences associate middle Javanese with their ancestors and specifically with the Majapahit empire of Java (1343–1515), from which much of their cultural heritage is derived. In mask dramas the language is spoken for the high-caste characters by their servants; the high-caste characters, who wear full-face masks, are unable to talk but express themselves through mime.

The clowns and servants in mask dramas use a range of languages that encompass all caste-related levels of Balinese as well as modern Indonesian. When speaking to a high-caste character, clowns and servants use high Balinese. When speaking to each other or to the audience, they speak middle Balinese or Indonesian. Low Balinese is considered very crude, but is used for jests or insults, especially near the conclusion of the drama.

MUSIC Mask drama in Bali is never performed without the accompaniment of a gamelan orchestra—a combination of gongs and drums—which create layers of sonority and can be alternately gentle and charming or robust and riotous. No social or religious occasion is complete without the music of the gamelan.

The resonance of the music is produced by the instruments and their tuning. Gamelan is a percussive orchestra including hanging gongs, metallophones, and kettle gongs made of bronze. Various other instruments may fill out the sound, for instance, the jew's-harp gamelan that accompanies the Frog Dance, a fable whose plot parallels the European fairy tale of the Frog Prince.

Players have equally important roles, though the drummer functions similarly to a conductor by setting the tempo. Players then take their cues from each other. Beneath the complexities of sound is a simple system: melodies repeat in cycles, with a gong marking the end of each cycle, while the lighter and more virtuosic instruments construct accents around the basic melody.

Masked dancers are expected to work with unfamiliar gamelan orchestras without benefit of a rehearsal. The musicians follow the dancers' movements. A performer halts to communicate, by either sound or mime, and the musicians stop playing the melody but maintain the rhythm. When movement resumes, the gamelan picks up the melody and accompanies the dancer until he pauses again.

PRODUCERS In the early kingdoms of Bali, dating from A.D. 1000, mask dances and performers were patronized by kings, who purchased and maintained the masks, costumes, and musical instruments and also sponsored the training of the performers. After 1900, Dutch rule diminished the power of these rulers, and the responsibility of producing dramas gradually fell to the *banjar*, a neighborhood decision-making organization consisting of around two hundred married men. Every village in Bali has at least one *banjar*. The families of the men in the *banjar* also belong to the group,

17

but only the patriarchs attend meetings. When the *banjar* becomes too large, another is started; hence large cities like Denpasar, the capital of Bali, have sixty-six *banjars*. These groups organize, support, and fund dance and gamelan groups composed of their own members. They may also employ renowned performers from another village for a special occasion, and if their own reputation grows, they may be invited to play in another village, in return for a donation and other amenities. Any income from a performance is used to purchase new musical instruments, props, or costumes, or for civic projects such as schools, roads, or temple repair.

Every *banjar* aspires to have the finest dance and gamelan group on the island, but only some villages have been able to establish a tradition of fine musicians and dancers. Gianyar district in central Bali, which encompasses the villages of Ubud, Peliatan, Singapadu, Teges, and Saba, is often referred to as the cultural center of Bali, and its prestigious performance groups have toured the world.

Besides performing for their own and other temple festivals, *banjars* also create performances designed especially for tourists as fundraising activities. Participants are exempt from other *banjar* duties in exchange for their services as performers, and skilled dancers from other areas may be commissioned to ensure high standards. Performances for tourists, generally of good quality, offer the benefits of early starting times, comfortable seats, effective lighting, and pared-down action that concentrates on comic and dramatic moments, dispensing with dialogue that would be hard for outsiders to understand. Since Balinese theater is usually held late at night and lasts until early dawn, and takes place in crowded situations without formal seating, many visitors enjoy tourist performances more than performances for local villagers.

Two other organizations that produce performances are STSI and SMKI (previously KOKAR), the island's major dance and music conservatories, located in Denpasar. SMKI is attended by high-school- age men and women, while STSI serves the university level. Exceptionally talented young people from all over Bali attend classes in drama, music, dance, and art, and publicly perform both traditional dances and new creations.

Some renowned performers, such as Made Jimat and Ketut Kantor of Batuan and Cokorda Raka Tisnu of Singapadu, have created their own performing companies, which include both family members and dancers from other villages. The companies have a repertoire of dramas available for public or private performance on a commission basis. If the members of a *banjar* decide to produce a new production of a traditional mask drama, they locate a director—usually the man closest at hand with the most experience—who interprets the drama, choreographs the performers, and in some cases trains the dancers. The director might be the leader of the gamelan, the head of the *banjar*, or an outstanding, experienced local dancer. A *banjar* may also commission a member of the STSI or SMKI faculty or a famous performer from another village to train actors and stage the production. Rehearsals are customarily held three times a week in the evening and last from one week to six months.

WOMEN Traditional Balinese drama details
the exploits of male heroes who are usually involved in a struggle for power. Female characters supply the romantic interest and, in the case of the Condong, a lady in waiting, an element of humor. Historically, men danced the few female roles, disguised by masks that transformed them into a wide range of characters, from demure, fair-skinned beauties with downcast eyes to horrifying, gloating witches.

Today, women perform as princesses, servants, angels, and goddesses without wearing masks. However, men continue to play the cruder, raspy-voiced witches, which call for the low-pitched tonalities of the male voice, and a dangerous proximity to black magic and trance. Women are rarely attracted to these roles because they necessitate the wearing of heavy cumbersome masks with wigs and unwieldy costumes, and entail difficult vocal requirements. Although women are not prohibited from portraying witches, they do face

social stigma. Any woman wishing to dance the part of a witch—especially Rangda—would be teased unmercifully. By contrast, women are often required to play the hero or god without wearing masks; it is felt that few men have the ability to perform the exquisite qualities of a deity.

Female performers rarely wear masks, even in commedia dell'arte, Chinese opera, or Native American rituals. Audiences want to see women's faces, rather than have them concealed. In Bali, the only mask worn by women is the infrequently performed Telek, the sly-eyed counterpart to the Jauk, in the Barong dance. These gentle, white-faced masks bear a strong resemblance to Javanese masks, suggesting that they have a lengthy history.

The village of Ketewel possesses some very old and venerated masks that are worn by Legong dancers. Legong, a sacred temple dance, is performed by unmasked prepubescent girls. Painted in different colors, the six masks resemble each other and are carved like Javanese masks, especially the interior bit held by the performer's teeth. The masks—considered too sacred to be photographed—are worn by three pairs of dancers performing in the inner sanctum of a temple.

COSTUMES AND SCENERY

The costumes for Balinese mask theater are based on the clothing of the Wayang Kulit, or shadow puppets. Originally quite simple, costumes were gradually embellished over time. Elaborate collars, complex headdresses, and gilded capes do not have specific historical antecedents, but slowly evolved to their present appearance.

The leather headdresses, with their intricate tooling, take the longest to produce, usually one month. The quickest item to execute is the stenciling of gold paint on capes and sarongs. A dancer who performs frequently must have his or her costume restenciled every three months.

Price and quality are of major concern to dancers, who in many cases must purchase their own costumes, or sometimes must borrow ill-fitting ones. *Sengkelat*, the best quality costume, is made of the finest material and is built to withstand stress. *Lakan*, the second-highest quality, is more commonly seen, and *bludru*, the last quality, is the most affordable. A complete Topeng costume, without masks, costs under two hundred dollars.

Except for the gray horsehair of the Topeng Tua wig, which comes from the island of Sumbawa,

19

east of Bali, all costumes are constructed in Bali with materials from Java, Singapore, and even Japan. There are costume makers in many villages, especially Tampaksiring, Denpasar, Puaya, and Sukawati.

The director of the dance group decides which characters will be masked and which will wear the heavy makeup that produces a masklike effect. For animals, demons, and clowns, makeup mirrors the design conventions of the corresponding mask.

Traditional Balinese mask theater has no stage, dressing room, or auditorium. A drama is held in an appropriate part of the village, open-air performances being the most common. Some dramas are performed in the large *bale banjar,* a pavilion centrally located in every village. The direction of the playing area is dictated by the cardinal points, which symbolically affect the entrances and exits of important characters.

The playing area, called *kalangan,* is always consecrated prior to a performance by the local priest, who prays and leaves offerings that remain in place throughout the drama. The floor is often dirt, occasionally cement or tile, and the audience sits, squats, or stands. Occasionally the village will rent folding chairs that the audience may use for a fee. The audience, especially the children, often spill into the backstage area and perch on any prop or set piece not in use.

Topeng is the only mask dance to use a curtain, and it is often small and nondescript. The witch's house is an important set piece in the Calonarang, which, like the Topeng, is performed in three-quarter round. The Barong Landung, Wayang Wong, and Barong procession are all performed in the round.

The few elements used to decorate the playing area include umbrellas, spears, and foliage taken from nearby trees. Carved palm-leaf decorations are sometimes hung in long fringed rows over the stage. The director decides what elements will be used and who will supply them. Lighting is simple. If the performance takes place after dark, neon lights are suspended over the stage, or occasionally kerosene lamps, which provide less illumination but create a more beautiful effect, are set on the ground. The exceptions, tourist performances, often take place on elevated proscenium stages, against painted backdrops depicting Balinese temples. The audience is comfortably seated in terraced rows, the sound is amplified by microphones, and the drama is illuminated with sophisticated lighting.

This book includes the most important masks used in Balinese ritual theater and procession, categorized by the name of the drama in which they appear. Barong and Rangda masks are the only ones used in procession as well as dance. Some minor characters, such as the fifteen to twenty masks of the monkey army in the Wayang Wong, have been excluded, as have a few of the demon servants of Rangda from the Calonarang. Some older sacred masks have been omitted because they are not allowed to be photographed; among them are the Ketewel Legong masks and the collection of Blahbatuh (possibly the oldest masks on the island). Each village has its own customs, versions of the stories, and names for many of the masks. Alternative names, if any, are given in the back of the book under List of Masks. Some dramas are presented in only a few villages, others throughout the island. Two of the masks are giant puppets, ten-foot-high costumed figures with attached masks, which are worn and performed by dancers.

A synopsis of each of the four dramas precedes the gallery of masks in each chapter. The carvers of each mask, when known, are credited in Carver Credits.

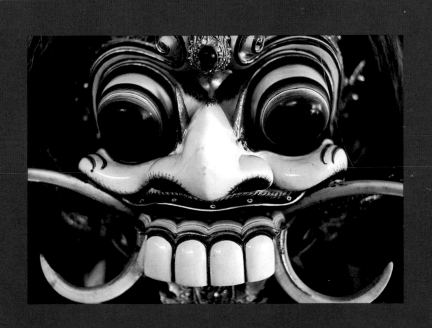

TOPENG

In the ancient dance drama of Topeng, ancestral history, Bali Hindu religion, and satire of regional situations are combined with music, dance, song and mime to celebrate the heroes of the past and their relevance to the contemporary workaday world. Like other traditional Balinese dances, Topeng traces its roots to the golden ages of India and Java. Ancient palm-leaf *lontar* books, which contain historical narratives and information about family histories, place the origins of Topeng at A.D. 840 and possibly earlier. The word *Topeng* is Javanese for "mask" and also means "something that is pressed against the face" in old Javanese, a derivation that likely gave the mesmerizing dance its name.

The stories presented in the Topeng, called *Babad Dalem (Chronicles of the Kings)*, are about the early kingdoms of Bali and Java and serve to preserve genealogical histories for modern Balinese. These mythopoetic sagas were conceived by Javanese and Balinese court poets hired to eulogize the historical exploits of their prospective feudal rulers. Only fragments of a story might be told in performance. It is unnecessary to produce an entire tale because villagers are already familiar with the exploits of the romantic and colorful characters in Balinese history. Topeng illustrates the relationship between past and present by taking an ancient story and modernizing it, thereby drawing parallels between contemporary people and historical figures. In this way, Topeng is an important teaching device used to communicate history, philosophy, and moral standards in an entertaining manner.

TOPENG PAJEGAN
Pajegan is a Balinese word referring to one person enacting the roles of several characters, essentially a one-man show, through which the actor/dancer establishes his expertise. He may captivate the audience with his sensitive portrayal of an elderly courtier, only to disappear behind the curtain and reemerge minutes later as a brassy young village girl. In the Topeng, more than any other form of mask drama, the performer must be a versatile actor because his skill is what makes the diverse characters come alive as distinct individuals.

The Bali Hindu version of Topeng Pajegan developed in the culturally rich courts of Gelgel and Klungkung during the seventeenth and eighteenth centuries, conceived by creative and imaginative court poets. The popularity of Topeng soon spread to other villages, nurtured by local princes who subsidized the elaborate masks and costumes and passed them down through succeeding generations. Eventually these treasures became embellished with the cumulative magic, or *sakti* of each ritual in which they were used, enhancing their power and value. The oldest Topeng masks of this type in Bali, dating from A.D. 1400–1500, are kept in the Pura Penataran Topeng temple of Blahbatuh in the Gianyar district.

Six of these masks are held in place with a mouthpiece, while fifteen are worn in the conventional manner. It is forbidden to photograph the masks, which are considered very sacred and are displayed only briefly on special occasions. Stored with the precious masks are a series of hallowed *lontar* books, chronicles etched on sheets of dried palm leaves that record how Topeng Pajegan originally may have come to Bali. In the sixteenth century, Balinese King Dalem Batu Renggong of Gelgel dispatched a war party to the Kingdom of Blambangan in East Java. One of the generals brought back the masks as spoils of war. They were then stored until the king's grandson brought them to life in a performance of the Topeng

Pajegan over a hundred years later. The premiere was an instant success, and enacting the Topeng on the birthday of the family temple in the royal palace of Gelgel became a tradition. The *lontar* books also contain a narrative of the battle between Dalem Renggong and the King of Blambangan, which still serves as a popular plot for Topeng performances throughout Bali.

The village of Ketewel also possesses old Topeng masks which villagers claim are four hundred years old. The masks appear as part of the annual village temple festival but are never touched directly. They are handled with a white cloth by the dancer and his assistant. Their features bear a strong resemblance to Javanese masks; the eyes and mouths are smaller than on other Balinese Topeng masks.

Topeng Pajegan is sometimes known as Topeng Wali because it takes place in the *jeroan*, the most sacred part of the temple. It may be performed at marriages, cremations, tooth filings, and other important rituals, but if it is presented at a temple festival, it always appears on the first day because of its religious aspect.

DANCERS The Topeng dancer functions in a capacity similar to a priest by calling upon his ancestors for help and support in an essential part of the ceremony held on the first night of the temple festival. A Topeng dancer must possess a variety of exacting skills. His movements are essentially improvised within a few fixed patterns. He must have a thorough knowledge of gamelan music in order to achieve the complex interplay between dancer and musicians. The dissonantly chanted language of all high-born characters in Topeng is Kawi, or old Javanese, and the performer must spend time studying this archaic poetical

form of speaking with a priest or local language master. Altogether, the performer should be fluent in the seven languages employed in Topeng: Sanskrit, Kawi, middle Javanese, high, middle, and low Balinese, and modern Indonesian. Since Topeng serves as a vehicle for teaching history and philosophy, the performer must be familiar with the ancient and sacred manuscripts and act responsibly in the interpretation of moral standards. When a dancer performs the role of an authority figure such as a prince or village leader, the values he espouses are expected to reflect Hindu philosophy. For these reasons, the Topeng dancer is often a mature or older man whose years and skill merit respect from the Balinese community.

TRAINING A Topeng dancer's career begins in his own village, where he has undoubtedly mastered less important dances such as Baris, the warrior dance performed without masks, or Jauk, a masked performance featured in the Barong dance. He studies the basic movement, philosophy, and character of each of the Topeng masks with a master dancer, who may be a family member. He imitates his teacher's version of each dance and, as he becomes more confidant, introduces his own style, variations, and improvisations. At his instructor's instigation, he humbly approaches the local priest or head of the village and asks permission to dance for the first time at a local festival. For this occasion, or later, when the dancer debuts in another village, he is purified in a special ceremony, called *mewinten*, by a Brahman priest and becomes "married" to his masks (*mesakapan prakulit*). Since dancing the Topeng often runs in a family, children inherit old masks that have been empowered with the spirits of many performances and festivals. Dancers also commission masks,

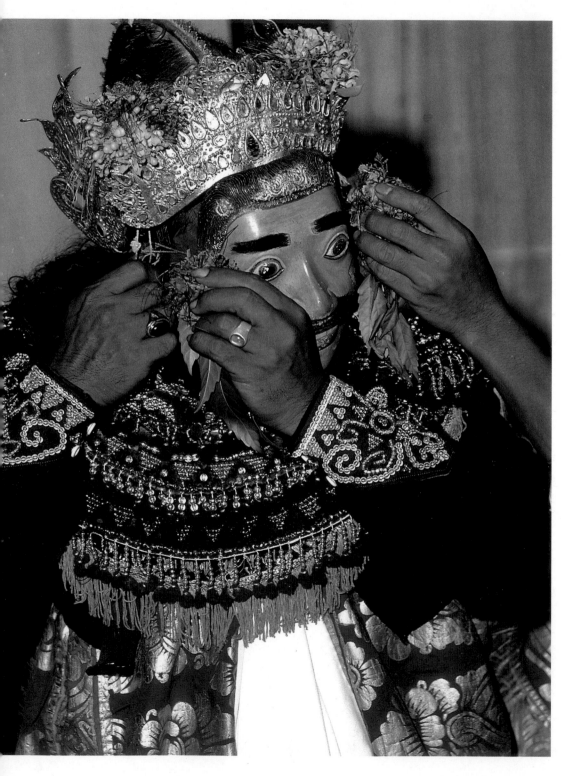

especially the grotesque clown masks that are the individual trademark of each dancer.

If a man establishes himself as a respected dancer in his own village, his reputation travels to other areas, and he is approached by a committee from another village, which invites him to dance at their ceremony. At this time they also inform him of local issues, such as a rivalry between prominent villagers or an indiscreet romance, as well as specific references and topical humor that they wish him to include in the performance. He then chooses the historical story that most closely parallels the village's situation and seeks out *lontar* books to refresh himself on the text and details.

Because of this element of didacticism, the Department of Information in Bali has commissioned Topeng companies to perform in villages and on television about family planning, politics, migration programs, and other subjects. In Hindu Java, the early rajas demanded that Topeng masks be held to the face by means of a wooden bit held in the teeth, which prevented the actor from speaking and ridiculing his king. During the Dutch and Japanese occupation in Bali in the twentieth century, some Topeng dancers who satirized their oppressors were imprisoned.

PERFORMANCE On the night before a performance, a dancer may receive a message of advice or support in his dreams from his ancestors or his gurus, or from the spirits of the masks. The next day he prays to these same protective spirits in his family temple where his performance masks are kept. He then packs his headdresses, masks, costumes, and some holy water and travels to the village where he is to perform. Upon arrival, he is offered betel nut, cigarettes, or *arak* (a potent liquor similar to vodka), food, and other beverages.

A period of casual socializing follows. During these several hours, the dancer familiarizes himself with the people and their temple. He then proceeds to swathe himself in the layers of fringed and gilded velvets and brocades that serve as the costume for all of the Topeng characters from king to clown. This complex dressing process is done

in leisurely style and in full view of any curious villager. The dancer makes two offerings, one to Siwa, God of Dancing, and the other to the *butas* and *kalas*, the low spirits, asking them to purify the performance area and not to disturb the dance.

These prayers are in the form of mantras, spoken in Kawi (the ritualized language that connects the dancer with the world of the divine) and serve to focus the dancer on the performance to come. He then taps the basket holding the masks three times to awaken the masks, transfers them to a small table near the entrance to the performing area, and arranges them according to the order in which they will be used. Removing the white cloth coverings from the masks, the dancer sprinkles them with holy water.

Audience and performer may wait for some time before the priest gives the signal that the auspicious moment has arrived for the dance to begin. During this time the performer may meditate, hoping to achieve the desired spiritual state of *ketakson*. The root of *ketakson* is *taksu*, divine inspiration also known as "the gift." Only one family member at a time can possess this treasure, which is bestowed by the ancestral spirits. A young dancer may postpone performing publicly until an accomplished and recognized older relative has died or retired. Every Balinese family temple contains a shrine dedicated to *taksu*, where those who have achieved it may give thanks and others may pray that they will acquire it.

When the propitious moment to begin the performance arrives, the dancer puts on his introductory mask, as well as an elaborate buffalo-hide headdress painted gold and decorated with fresh flowers and burning incense. A partial black wig of human hair, attached to the crown of the headdress, falls down his back, and clusters of leaves are arranged at his temples, concealing the separation of mask and headdress. The dancer positions himself on a high-backed chair behind an improvised curtain, usually no larger than double doors and made of cotton hung on a bamboo rod. Beyond the curtain and the performing area is the village temple, where the gods, as honored guests, have been invited to sit. The dirt-floored playing area is no larger than twelve feet across and is surrounded on three sides by expectant villagers, children sitting cross-legged in the front row, and adults crowded in behind them. The lively music of the village gamelan orchestra draws the audience's attention, signaling the beginning of the dance.

The dancer utters a low, guttural exclamation, and the curtain trembles with the rhythms of the gamelan, heightening the tension and intriguing the audience. The curtain slowly parts to reveal the Patih (Prime Minister), signaling the first of a series of pengelembar, or introductory dances, which acquaint the villagers with the performer's skill and set the mood for what follows. This angular and exacting dance may be followed by the Patih Kras, a prime minister of a slightly different nature; Topeng Tua, the Elder Statesman; or Dalem, the King—each of which requires a change of mask, character, or personality.

After the performer presents the introductory characters, the mood changes with the entrance of the half-masked, speaking characters, who advance the action of the story. The first to emerge is the Penasar Kelihan, the servant of the Prime Minister and a self-important comedian. He lays the groundwork for the story in Balinese vernacular interspersed with good-natured clowning and obscenities. After summarizing events that have already occurred, he calls upon his master to enter and "reveal" himself. At this point, the dancer may become the voice for the unseen Prime Minister, chanting his dialogue in ritualized Sanskrit and drawing the observers into the world of the past. The Prime Minister, or Patih, communicates for the Dalem, his King, who is rendered mute by both his full-face mask and his exalted position. The dancer then exits, switches masks and headdresses, and reemerges minutes later as the Prime Minister. What follows is a sequence where the performer alternates masks and characters. The half-masked clown characters move the action forward through speech, and the fully masked high-born characters lyrically entertain through mime and gesture. The complexities of one actor changing from character to character are partially solved by changes in language that enable

the audience to identify who is speaking, or being spoken for, at any given time.

After a brief and seemingly sketchy tribute to the plot, a series of *bondres*, or clown characters, emerges, whose relationship to the story seems to be somewhat thin. Favorites of the audience, the clowns parody the idiosyncrasies and handicaps of local villagers. The broad, slapstick humor delights the audience and brings elements of the present into the historical narrative. The parade of *bondres* characters continues as long as the audience's laughter, attention, and support is with the performer. The antagonist, the enemy King, then appears. He has a decidedly rough and offensive appearance and behavior, and is followed by the Prime Minister, who concludes the action symbolically, by defeating the antagonist.

Topeng Pajegan is sometimes called Topeng Sidha Karya, in honor of the appearance of the final character, who is not connected to the story. It is the depiction of this leering, supernatural white-faced being, without whom the sacred ceremony cannot be a success, that the religious aspect of the drama reaches a climax. As the time for his entrance approaches, one can feel the anticipation of the village children, who are the targets of his attention. The wild-haired character claims an offering from the high priest. Chanting and laughing, he performs a blessing and throws holy water and a handful of Chinese coins and yellow rice, ritualized souvenirs of the occasion, to the delighted audience. Finally, he scrambles into the crowd of shrieking children, seizing one and carrying him or her to the performance area to be blessed by the gods before being sent off with a token offering.

After this dance, the performer disappears for the last time behind the curtain to remove his sweat-soaked costume. He is given a special offering with prescribed contents to take to his family temple, along with his masks, and whatever payment has been agreed upon in return for his services. If he has a connection with the temple or with friends and family in the village, the performance may be an offering to the gods. The Topeng Pajegan performer's most important obligation is to fulfill the needs of the ceremony. In the case of

the god ceremonies (such as temple festivals), his role is most crucial, for in this situation he functions like a priest. Sometimes his dance may serve as the entire ritual for the opening night of a festival. On other occasions, such as cremations and consecrations, his performance may be more humorous and relaxed. Regardless of the type of performance, the spiritual and ethical dimensions of the dancer's everyday life must be exemplary, or he will be considered unclean and not invited to perform.

The exceptional abilities demanded of the Topeng performer's skill and imagination help make the normally static masks seem animated and alive. The dancer, through sheer concentration and subtle movements of the head, enlivens the fixated stare of the mask. He distorts his lower jaw so that it joins the painted upper lip of his clown mask in a perfect semblance of believability. Caressing the beveled wood of his artificial mustache, he tilts his head in such a practiced manner that the mask's wood visage seems to assume myriad expressions. The grace and fluidity of his gestures never belie the fact that he may be several decades older than the amorous hero he portrays.

TOPENG PANCA There used to be many more performers of Topeng Pajegan in Bali than there are now (presently fewer than fifteen). At the end of the nineteenth century, five of the finest performers were patronized by the last King of Badung (now known as Denpasar). The leader of the group, inspired by the collective talent, organized a new theatrical form purely for the entertainment of the court. It was given the name of Topeng Panca, the latter word meaning "five," although today this drama may be performed by eight to ten, rather than five, performers.

This Topeng uses the same stories as Topeng Pajegan, but the action moves faster because there is greater interchange between the onstage characters. Penasar Kelihan and his younger brother, Penasar Cenikan, indulge in numerous comedy routines and are always present on stage as interpreters for those masked characters who do not

speak. After the court of Badung was annihilated by the Dutch in 1906, the five-man troupe toured the island, popularizing the new Topeng Panca, and today many companies are in existence. This version of the Topeng is never performed in a temple, and the Sidha Karya character is omitted.

THE STORY OF SIDHA KARYA

During the Gelgel dynasty (1550–1639), a large temple festival was held in the Mother Temple of Besakih. *Nangluk Merana*, the festival's name, means "to preserve from pests." A Brahman from Keling in Java came to Bali to test the spiritual strength of the King of Gelgel. He disguised himself as a beggar and arrived in Besakih dirty and ragged. Mingling with the well-dressed people attending the ceremony, he was stopped by the Prime Minister. The Brahman told the Prime Minister that he was related to King Waturenggong, the ruler of Gelgel, but the Minister, seeing only the beggar, decided this was impossible and sent him away. The Brahman went to the area of southern Denpasar, now called Sidha Karya, and from there he devised a mantra that created havoc: animals died, flowers ceased to bloom, trees stopped bearing fruit, and the land became barren.

Devastated by what was becoming of his country, the King of Gelgel went to Besakih temple to meditate. There he heard a voice that told him of the Brahman at southern Denpasar: "If you wish to restore the land, you must call him back. He is your brother." The King summoned his Prime Minister to find the Brahman. The Minister did so, and when they returned, the King explained his problem: "The chickens are dying, the trees refuse to bear fruit, the flowers to bloom." The Brahman told him to look outside. "You see the flowers now bloom, the animals live, the trees bear fruit, and everything is flourishing." After that the King of Gelgel believed the man was his relative, and called him "brother." He also changed the Brahman's name to Dalem Sidha Karya. Since that time, sacred Topeng performed at every ceremony ends with the dance of Sidha Karya. *Sidha* means

"able"; *Karya*, "ceremony." Without the blessing of Sidha Karya, the ceremony is incomplete. Today, when the Balinese plan a large temple festival, they bring a special offering to the shrine of Sidha Karya village and request some holy water for their family temple festival.

In this drama, the King wears the Dalem mask, and the Prime Minister, the Patih Kras. The Penasar appear as servants to the Minister, the *bondres* masks as various villagers from the Besakih area, and Sidha Karya as himself. The Topeng Tua mask is not used.

PATIH MANIS

The first mask revealed in the series of introductory dances that precede the story of the Topeng is usually that of the Patih Manis, or Prime Minister. This character reflects the so-called rough personality types by exhibiting tendencies toward pride, foolishness, and ambition. As strategist, decision maker, and advisor to the King, or Dalem, he is clever and cunning, and is occasionally involved in political and romantic intrigues. The mask pictured here is worn if the Patih in a drama is more *manis*, or "sweet natured."

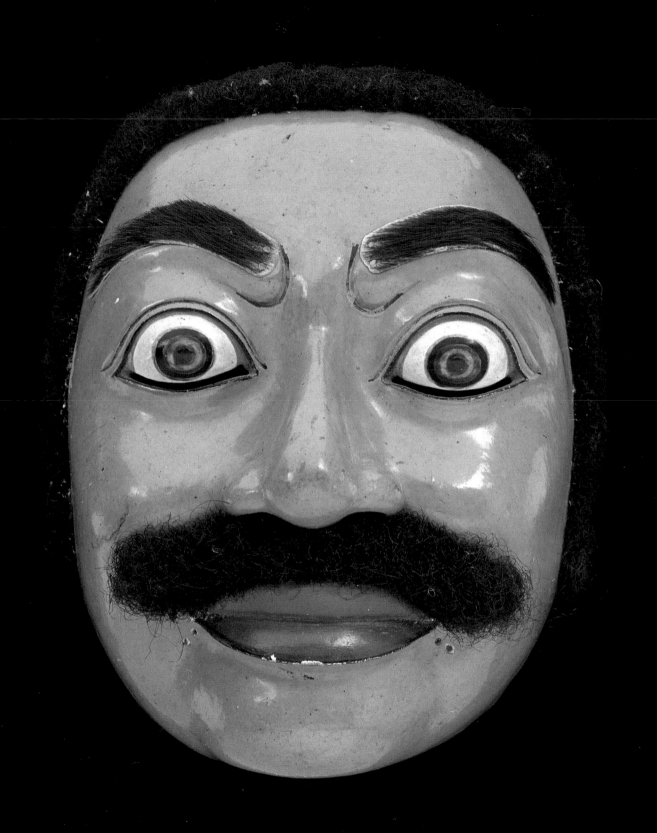

TOPENG TUA

The second mask used during the introductory dances is the Topeng Tua, which may reemerge later in the drama as the Senior Minister, Wise Elder Statesman, or King in Retirement. Possessing a good deal of pathos, this character exhibits great dignity and inner strength as well as a childlike innocence. During his dance, he demonstrates moments of great energy, rushing off to accomplish some great task, only to have his knees or lungs give out, a casualty of his advancing years. His slight smile enhances the comic moments of a drama, as when he discovers a flea in his clothing or lice in his hair.

As the curtain parts, the Topeng Tua is revealed sitting in a chair, his full mane of white hair falling about his shoulders. He lifts his jeweled fingers with aged grace. Slowly standing, he surveys his audience. By the conclusion of his brief dance, the audience has experienced his tenderness, sadness, and hilarity.

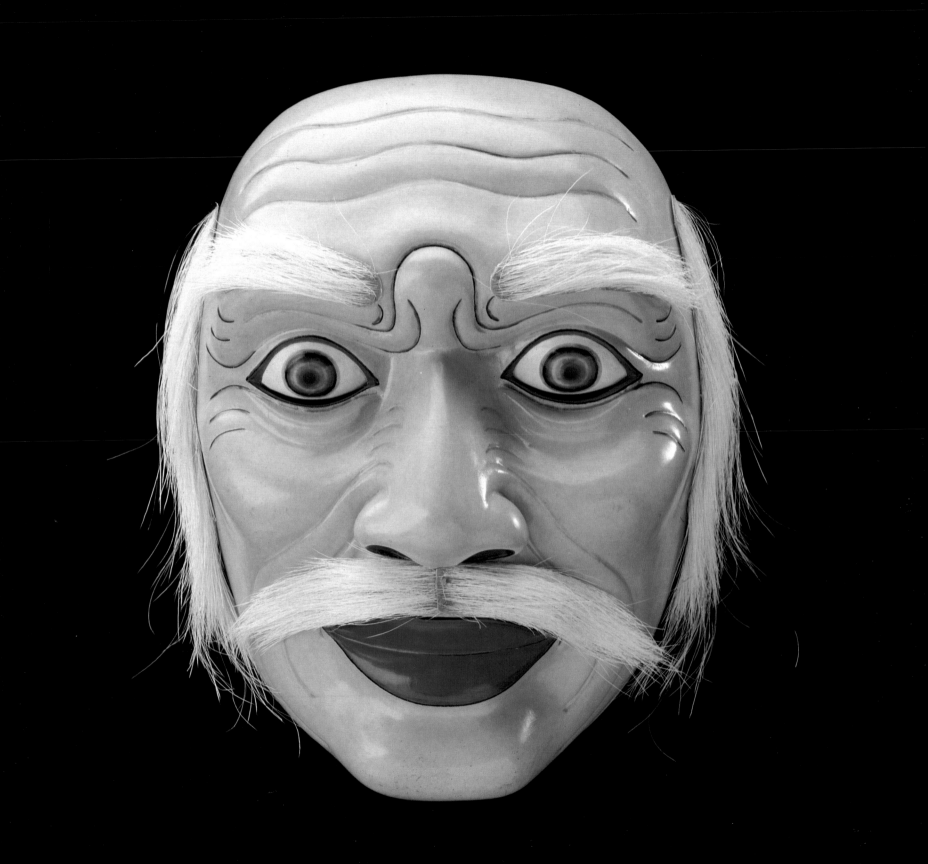

DALEM

The handsome Dalem, the Raja or King, usually appears third in the introductory dances to the Topeng, then reemerges as a character in the main story. The mask would also be worn by any hero-king of a story. It represents the qualities desirable in a ruler: intelligence, nobility, and a forceful, positive disposition. The carver strives to create unconventional good looks, for the Dalem is often the romantic hero, and traditionally had many wives and concubines. Often called Topeng Manis or Arsa Wijaya, the dance of the Dalem is performed with consummate grace and style, reflecting the inner beauty and refinement of the demigod.

The white complexion of the Dalem signifies cleanliness, purity, and an upstanding moral attitude; some Dalem masks are painted green to reflect other types of personalities, depending on the story. The almond shape of the eyes conveys an expressive intensity that contrasts with the feeling projected by Dalem's wide-eyed servants and squinting clowns. The hair, sleek and finely tooled, is topped by a crown of gold leaf. In the center of the forehead is a *cuda manik*, usually painted gold, which represents the third eye and is a symbol of Dalem's knowledge.

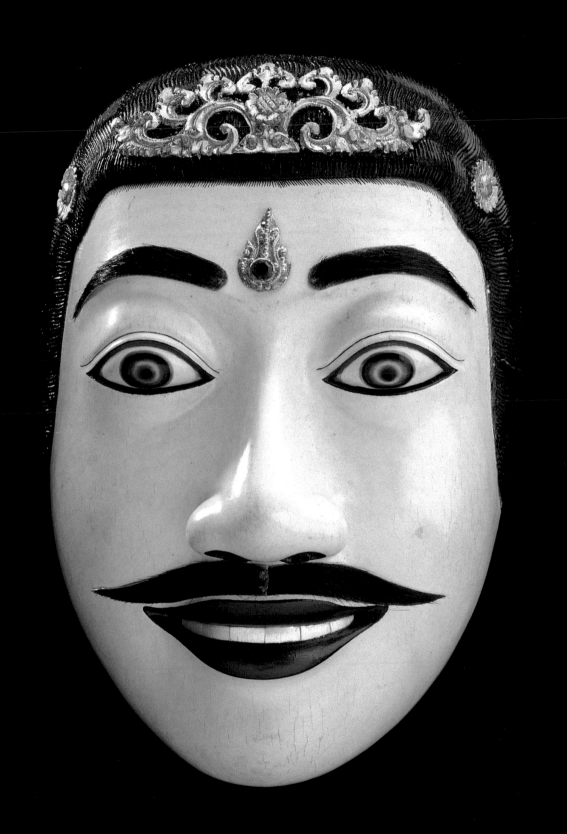

RAJA PUTRI

Just as the Dalem represents the ideal King, the Raja Putri, or Queen, exemplifies the perfect noble-woman: beautiful, refined, charming, and blessed with a clever mind. This mask may also represent the wife of the Prime Minister or any high-born woman. The features are as delicate and detailed as those of the Dalem mask, but in many instances the eyes are carved with a slightly downcast look to give the character a somewhat subservient demeanor. The mask is designed to conceal the identity of the male dancer, who formerly performed the role. The dance of this character, originally a solo dance requiring great skills, is rarely performed today.

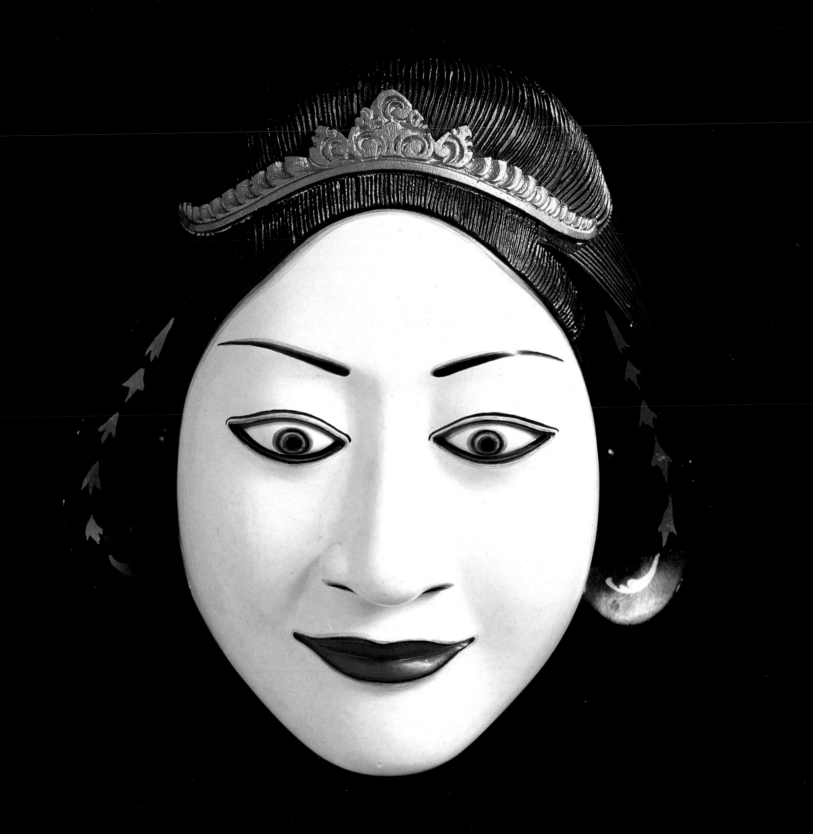

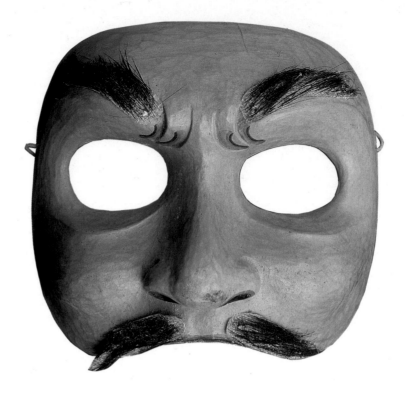

PENASAR CENIKAN

A great favorite of the Balinese audiences, the younger brother of the clown servants sings or speaks his dialogue in local vernacular interlaced with witty comments. Whereas his brother, Penasar Kelihan, narrates, Penasar Cenikan perceives the action of the play in a humorous way. No one escapes his ridicule, from his pompous boss to his obese older brother. Penasar Cenikan is always the "little guy," and the dancer who performs the role in mask drama is costumed to exaggerate his small, skinny physique. He is the only character in mask drama with exposed arms, which he flaps about like plucked bird wings. Also known as Kartala (a name that dates back to early Javanese Malat stories), Penasar Cenikan has the clearest idea of what is going on in the plot and sees the true nature of the characters. In many ways he is the mask with which the audience most identifies— the clever underdog who must survive by his wits. *(Above)*

PENASAR KELIHAN

The elder brother of the two clown servants to the central character of the story, the Penasar Kelihan is the proud and pompous comic foil for his more wiry and clever younger brother, Penasar Cenikan. Like his twentieth century Western counterpart, Oliver Hardy of the Laurel and Hardy team, he has an elevated image of himself which is reflected in the mask's large bulk and bulbous eyes. He takes himself very seriously, and is the straight man of the comedy duo and the butt of his brother's jokes. As the more talkative of the brother team, he has the task of narrating the action and background of the plot.

Before Penasar Kelihan enters the performing area, the audience hears his sonorous voice from behind the curtain as he sings the praises of his master. His enormous eyes, which give him a constantly startled look, contrast with his pursed mouth and delicately manicured mustache. He does not seem to possess a neck: the dancer is swathed in layers of clothing to give him a large body; and he can move only his arms and legs. *(Right)*

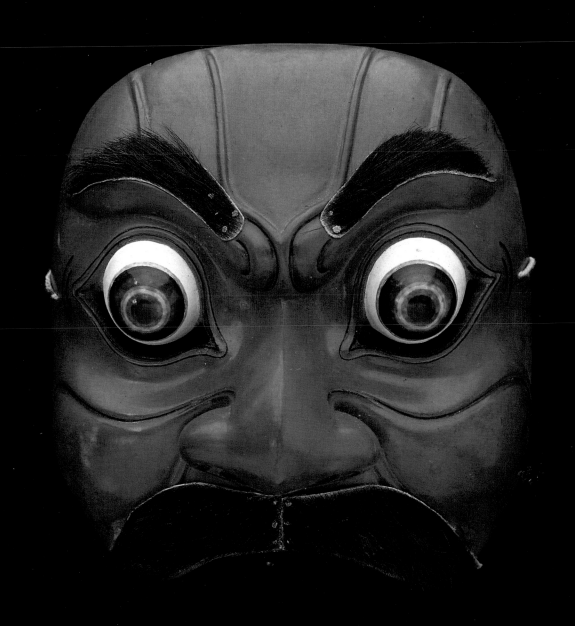

BONDRES
PASEK BENDESA

Each dancer has his own unique collection of *bondres* (clown) masks. This particular character is the warmhearted old head of the village. His wisdom has merited him the position of advisor to the Dalem, or King, and his sense of humor endears him to the village people, who chose him to represent them. He loves to joke and laugh, but has lost most of his teeth, a fact he tries to hide as he confesses to feeling young inside and still enjoying the company of women. He knows a great deal about religious and secular village life, and his expansive feelings for others endear him to the audience.

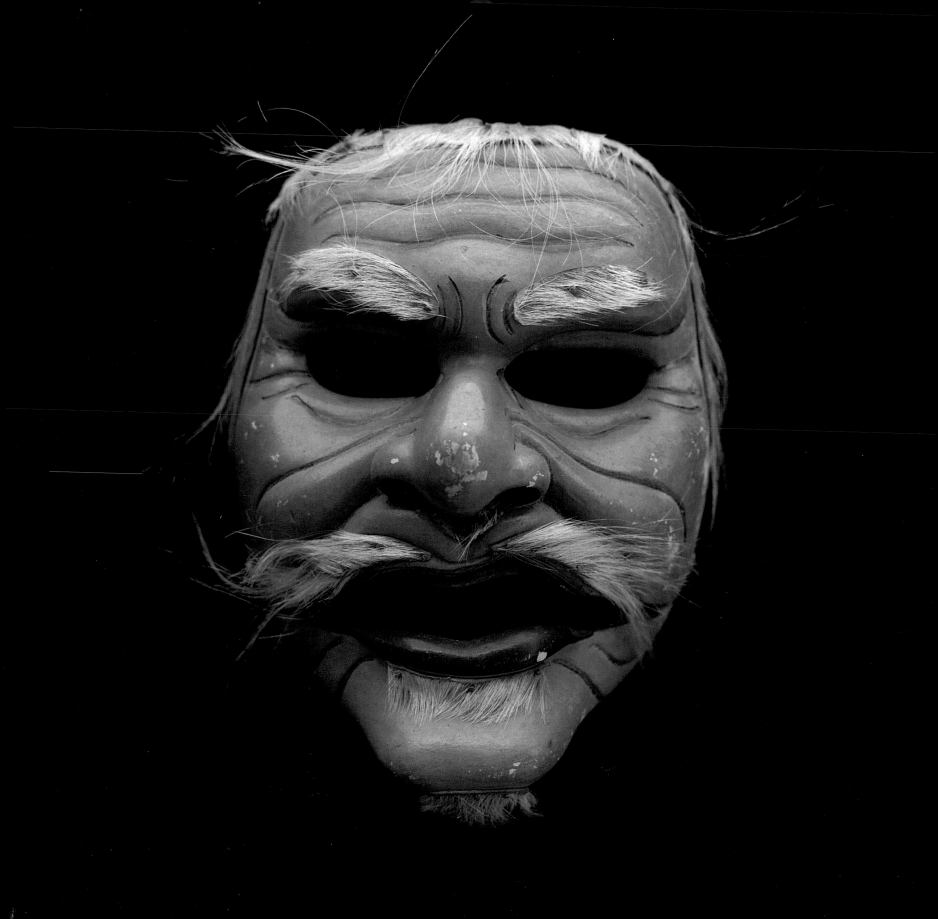

BONDRES KETE

This unfortunate, stuttering clown had been an accomplished dancer and singer before he was injured in a motorbike accident. After being under a doctor's care for six days, he emerged from his ordeal with a limp. Most of his dialogue focuses on the happier days before his accident. He serves as an example of the hazards of reckless driving. In earlier times, the infirmity of this traditional character in the Topeng repertory was attributed to other causes.

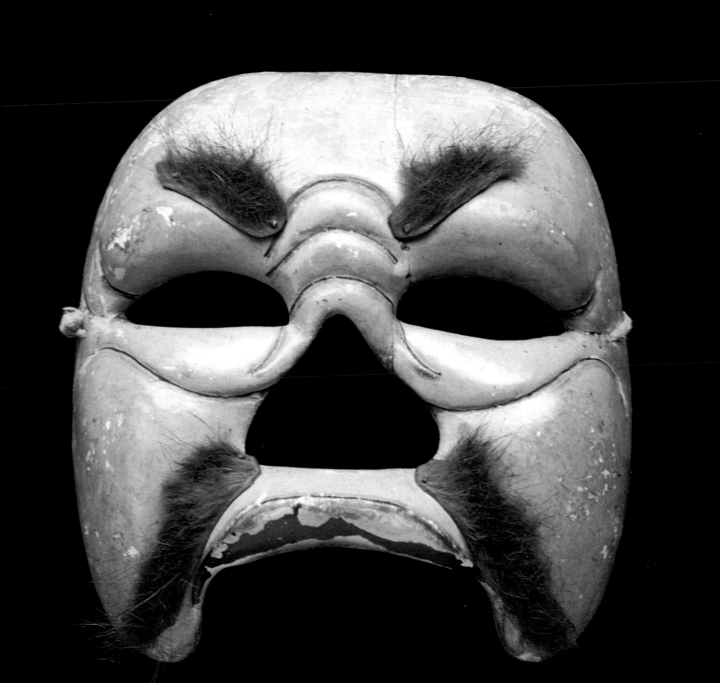

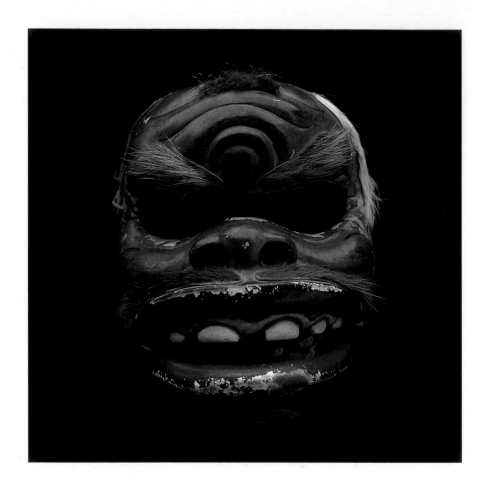

BUNGUT BUES

He is the archetypical town drunk in a society where it is an anathema to alter one's state of consciousness. As he speaks, his mind jumps from one topic to another in a confused ramble. A bit of a bully, he is always ready for a fight, and when he is not drinking, he is practicing martial arts. The arrogant and lusty Bues is constantly wondering where he will find his next drink. *(Above)*

BONDRES CUNGIH

This bucktoothed, harelipped clown is a trickster who enjoys making puns and double entendres to annoy the head of the village. A gadfly to authority figures, he is often lazy and uses his wit to avoid doing the community service work required of all villagers. Although he possesses a large repertoire of songs, he has difficulty singing because of his impediment. *(Right)*

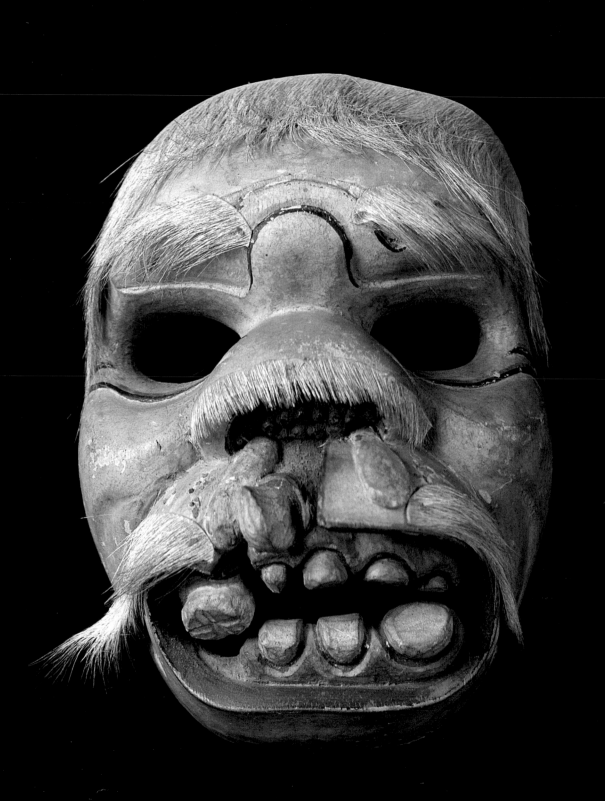

NYOMAN SEMARIANI

Although this genial and unusual-looking clown is not particularly bright, she is an excellent vocalist and a dancer of some grace. She has, however, passed the usual age for marriage (age thirty in Bali)—a constant source of worry for her. The pathos of her situation is emphasized by her jokes about her search for a young lover and her constant flirting with members of the audience.

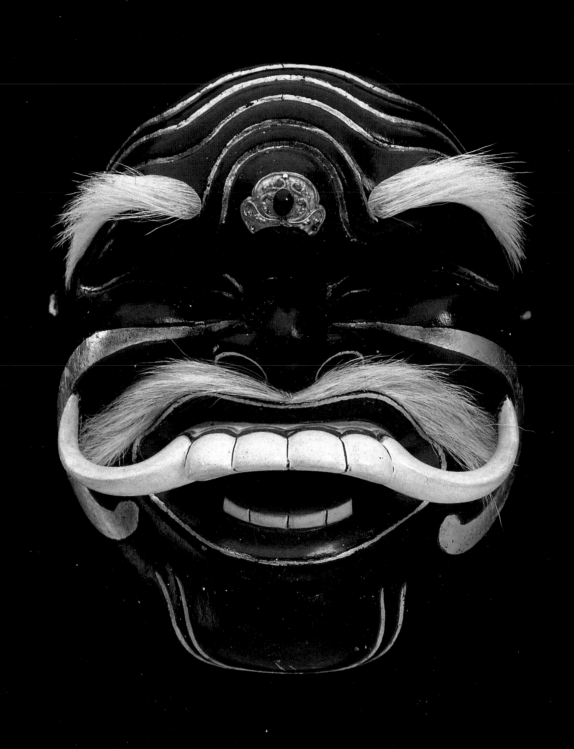

WAYANG WONG

The heroes of the great Hindu epics, the *Ramayana* and *Mahabharata*, have served as role models for the Balinese for many generations. In the Wayang Wong, the ancient stories of the *Ramayana* are converted to mask dramas enacting the battle between truth and justice and the forces of evil. Also providing the Balinese with positive images of behavior, Wayang Wong nurtures the belief that acts of courage, love, fidelity, and endurance are rewarding and lead to individual fulfillment.

In the story dramatized in the Wayang Wong, Rama, the virtuous hero and the incarnation of the God Wisnu, represents the spiritual world, and his loyal wife, Sita, the material world. Their adversary, the demon King Rawana, embodies greed and selfishness. Including these and other characters, the Wayang Wong combines narrative literature, dramatic spectacle, and elements of Wayang Kulit shadow puppet drama. The name *Wayang Wong* literally translates as "shadow men," and the movements of the dancers in many ways imitate the jerky animation of the Wayang Kulit puppets.

Although there is no recorded information about the origins of Wayang Wong in Bali, it is thought to have been performed in the seventeenth or eighteenth century during the Klungkung regency as part of a fertility dance called Barong Kedingkling. Held in conjunction with the Balinese festival of Galungan, the dance was performed during a ceremony that repelled evil spirits and chased destructive pests from fruit trees. The Raja of Klungkung ordered his court dancers to reorganize the sacred masks of the fertility dance into a new drama, using the *Ramayana* as a script source and the shadow puppet theater as inspiration.

The Wayang Wong is performed annually, usually in conjunction with the birthday celebration of the *pura desa*, the ancestral temple in each village.

There are currently nineteen places in Bali where the Wayang Wong is performed: Batuan, Mas, Pujung, Blahkiuh, Kaler, Den Tyis, Marga, Klating, Apuan, Tunjuk, Sulahan, Bualu, Teja Kula, Telepud, Bangbang, Kamasan, Wates Tengah, Batuagung, and Perancak. Each village possesses a set of sacred masks used in the dance, which are stored somewhere in the temple complex, awaiting their annual performance.

PERFORMANCE Before rehearsing Wayang Wong, the dancers, musicians, and narrators in the performing company go to a temple to pray to the Supreme God, Sanghyang Widhi Wasa, for solidarity and a strong, unified presentation. They bring a special offering called *pejati*. Then, about twenty days prior to the performance, the group begins nightly rehearsals under the leadership of the village dance director and his assistant. The characters are assigned according to the ability of the performers, and the central roles are performed by trained dancers. An actor keeps a role for life and teaches a younger member of his village to take his place in case of illness or death. During the first few rehearsals, performers review the story and dialogue. Because the play is not scripted, performers work together to create their dialogue, improvising when necessary and trying to achieve a balance between their roles and the role of the narrator, or Juru Tandak. The day of the performance, the performers again pray together in the temple, then adjourn to the dressing area to get into costume.

In some villages, the Wayang Wong episodes may be spread out over several days and may not be performed in sequence. Details of the story and which segments are performed vary from village to village. Sequence is inconsequential to the viewing

audience, who are completely familiar with the characters and story.

The clarity of the story and its themes, the assortment of colorful characters, and the spectacle of the masks, headdresses, and costumes makes the *Ramayana* among the most entertaining and easily understood dramas in the Balinese theater. For the villagers, however, the greatest pleasure lies in hearing Kawi, or old Javanese, an especially beautiful language used for poetic forms in Bali and Java. The responsibility for the recitation of Kawi lies with the Juru Tandak, usually one, sometimes two men who narrate the play except for brief interchanges between the characters. They are highly trained singers, often professional *dalang*, or shadow puppeteers, who use subtle voice changes to distinguish between characters. Because of the demands made on their talent and endurance, the narrators are key figures in the performance.

The play begins with the appealing percussive music of the Gender Wayang, the same gamelan music that is used for the shadow puppet play. There are no curtains or backdrops, and the only decorations are a few umbrellas around the periphery of the performing area.

The servants of Rama, wearing oversized makeshift costumes, lumber into the performance area. The clear voice of a narrator chants the action between the popular clown Twalen, also called Malen, and his son, Merdah. Anticipating the appearance of the central characters, they bow and look expectantly toward the point of entry. Rama and his brother emerge with slow, gliding movements. The aroma of perfume, created by sticks of incense elegantly extending from the performers' headdresses, follows them in wafting patterns. They luxuriate in economy of movement, impassive to comedy and conflict alike. The two monkey armies enter, prancing on long arched tails curving up from their posteriors. Dancing in unison, they form lines led by their rival kings, Subali and Sugriwa, who are brothers, occasionally speaking in rough, ferocious tones. The liveliest of the monkeys, the one whose entrance creates the most excitement, is Hanuman, the central manipulator of the action. The performer who plays him must be a dancer, acrobat, comic, and mime of great skill.

Long stretches of narration and minimal action follow, interspersed with confrontations between the warring factions. Animals appear, salute the central characters, and exit. After about two hours, the performance is over. The crowd melts away, only to regroup several hours later to watch another segment of the story.

THE MASKS Although all characters in the traditional Wayang Wong were masked, some villages have dropped this convention, especially for the *halus*, or refined, characters: Rama, Sita, Dewi Tara (servant to Sita), Laksmana (Rama's younger brother), and Wibisana (the brother of Rawana, the demon King). This allows for greater variety of facial expression as well as clarity of speech. The animal masks are not realistic portrayals. Rather, the monkeys, birds, deer, and other creatures in the story are fantastical beings who can speak, transform themselves, and create powerful magic. Some are endowed with a spiritual strength that renders them invincible.

The masks of the Wayang Wong are unique in Balinese drama in that they are attached to a headdress and sometimes include wigs that cover the head of the performer. The headdress is made of tooled leather, painted gold and decorated with fresh flowers. The wigs are of human hair. The masks, originating in designs from sixteenth century Java, appear to have been influenced by

stylistic motifs from an earlier period in China. The carved wooden lions housed inside Balinese shrines to symbolize the deities are similar in style. Some artistic conventions in the masks have counterparts in shadow puppet drama but are differentiated by design and color. Monkey and demon masks have bulging eyes and large open mouths revealing the teeth. Refined characters are carved with graceful, almond-shaped eyes, curled upper lips, and exposed, even teeth. Clown servants have squinty or bulging eyes with slightly open, smiling mouths. The twenty-seven different costumes are also highly specific in their color symbolism: red, for example, is used for happy, energetic, dynamic, and courageous personalities (demons and monkeys); yellow for discreet, wise, and sympathetic characters (Laksmana and Wibisana); and green for outgoing, peace-loving, and contented personalities (Rama).

In the demon and animal masks, the three small horns, one in the center apex of the forehead and two at the temples, are symbols of magic power. Between the brows, where the third eye is said to exist, is the *cuda manik*, symbol of the cycle of life. The base represents Candra, the crescent moon; the circle, Ardah, the sun; and the flare, Lintang Tranggana, the star. Each earlobe of the male characters is adorned with a large ring called *rumbing*.

The stylistic convention of portraying animals and demons with prominent teeth and exaggerated fangs is connected to Bali Hindu philosophy. One of the Balinese rites of passage is the tooth-filing ceremony. If this rite of passage is not performed during a person's life, it is performed after death to ensure that the individual will not be aggressive when he or she meets the gods and goddesses. The tooth filing is both an elaborate and expensive ceremony set inside the family home and temple. Several young men and women, usually in their teens, wearing elaborately embroidered garments, batiks, and fresh flowers, each recline on a dais while a priest, in five deft strokes, files the canine teeth to release the coarse, animal energy stored within them. The participants, having thereby distanced themselves from the community of lower beings, experience an intensely religious ritual and

are left with a beautifully even smile. Reflecting this practice, the animal masks, including frogs, birds, deer, and ducks, have long menacing fangs and rows of sharp pointed teeth.

THE RAMAYANA STORY The Ramayana was written by the Hindu sage Valmiki in the third or fourth century B.C., but versions recorded in *lontar* books and passed down through generations in Balinese villages vary.

According to the basic story, Rama, an incarnation of the God Wisnu, is robbed by his father's second wife of his rightful position as heir to the throne of the kingdom of Kosala in India and is banished to the forest of Dandaka for fourteen years. He is accompanied by his faithful and beautiful wife, Sita, and his steadfast younger brother, Laksmana. While in the forest, Sarpakenaka, sister to demon King Rawana, discovers them and is determined to seduce Rama and Laksmana. Although Sarpakenaka wears a beguiling disguise, Laksmana senses her true nature and cuts off her nose and ears. The outraged demoness flies to her brother's palace in Alengka to lodge a complaint.

Rawana seeks out Rama, Sita, and Laksmana in the forest, becomes infatuated with Sita, and decides to abduct her. He commands his minister, Marica, to transform himself into a golden deer and to prance enticingly within Sita's sight. The ploy works, and Sita, desiring the deer as a pet, implores Rama to capture it. He departs in search of the deer, first instructing his brother not to leave Sita alone. Rama's arrow mortally wounds the deer, which resumes the demon shape of Marica before dying and calls for help by imitating Rama's voice. Laksmana hears what he believes to be his brother and at Sita's urging sets off to assist him. Rawana, disguising himself as a priest, seizes this opportunity to gain access to Sita and carries her off to his palace. Rama and Laksmana return, only to find Sita gone and no clue to her whereabouts. The brothers begin their search and discover an old friend, Jatayu, the King of Birds, who encountered Rawana with Sita in his grasp and made a futile attempt to rescue her, only to have his wings lopped off by the vicious demon King. As the noble

bird's life ebbs away, he informs Rama of the kidnapping. Now Rama knows the powerful force against which he must struggle in order to rescue his wife.

Rama receives the aid of the monkey army of Sugriwa, one of the monkey kings, and the services of the outstanding white monkey, Hanuman, by helping Sugriwa retrieve his lover, Dewi Tara, from the grasp of his brother, Subali. The story of the argument between these two brothers is sometimes performed as part of the classical Legong dance, where two prepubescent girls enact the story of the monkey kings.

PART I: HANUMAN KAUTUS The first of the three sequences of the Wayang Wong dance drama in the village of Batuan begins with this episode, which means "Hanuman the Emissary."

Twalen and Merdah, Rama's servants, enter and act as storytellers by briefing the audience on the previous action. They bemoan Sita's abduction, commiserate with Rama, and set the scene for what is coming. They go to see Sugriwa, one of the monkey kings, to arrange a meeting with Rama. Sugriwa assembles all of his monkey army and other animals: the cow, buffalo, deer, lion, bird, goat, and dragon. The entire company makes its way to the forest of Resiamuka, where Rama and Laksmana, his brother, are camped. There, they discuss tactics and strategy to rescue Sita. A decision is made to send the white monkey, Hanuman, to Rawana's palace at Alengka to locate Sita and determine Rawana's strength. The scene then changes to Rawana's Court of Giants in Alengka where Delem and Sangut, the servants to Rawana, are talking enthusiastically about Sita's presence and see it as a positive omen for their country. In acquiring a wife, their king will reflect his pleasure by bestowing gifts on his servants. After a short time, they seek out Rawana to be briefed on the current situation and discover his needs.

Rawana expresses his desire to pursue yet another attempt at making love to Sita, who has vigorously resisted his attention. He formulates a plot to bring her a severed head, declare it to be Rama's, and claim himself as her new lover. Sita

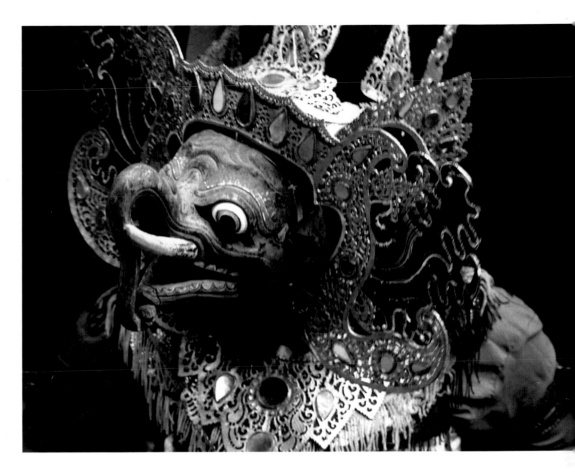

sees through the ruse, much to Rawana's frustration. Meanwhile, Hanuman arrives in Alengka and tries to find Sita. He doesn't know what she looks like, except that by reputation she is the most beautiful woman in the world. Rama told him that she would be "crying and pursued by demons." Hanuman transforms himself into a fly and spies Rawana trying to seduce Sita. When Rawana's efforts are thwarted and he leaves, Hanuman becomes his original self and introduces himself to Sita. He tells her that he is the leader of Rama's monkey army and has come to Alengka at Rama's instigation. But Sita believes he is actually Rawana, attempting one of his tricks. Hanuman shows her the ring Rama gave him, and she is finally convinced. Taking the ring, Sita hands Hanuman a letter and a hair clip, the latter a symbol of her steadfast love, to be conveyed to Rama.

51

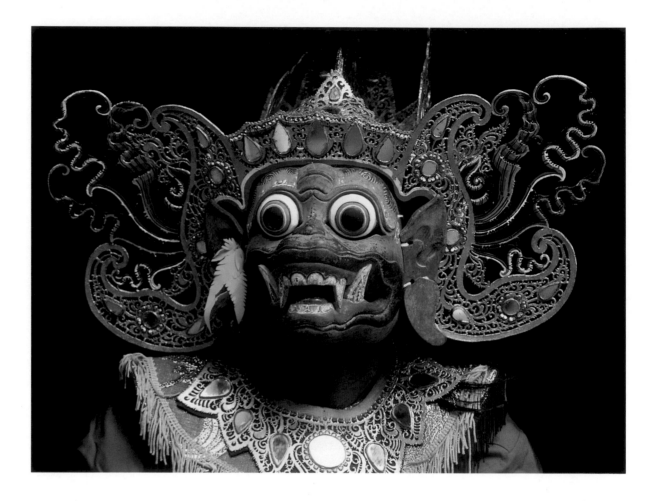

After leaving Sita, Hanuman flies into a rage, tearing apart a tree and using the branches to destroy the demons' royal palace. The security guards attack Hanuman, but he overwhelms them with his supernatural powers and uses their own weapons against the demon force. The guards call for one of Rawana's sons, Meganada, to join them. Hanuman wishes to test Rawana's power, so he allows himself to be caught and taken to Rawana's chamber. There, Hanuman taunts the demon King by telling him that Rama's impressive army is close by and will defeat him. Overwhelmed with anger, Rawana beats Hanuman with every implement within his grasp and tries to kill him. He is stopped by his brother, Wibisana, who pleads that Hanuman be spared as an emissary from Rama, advice Rawana ignores. Hanuman defiantly counters that Rawana will be able to destroy him only with fire. The demon guards dutifully tie Hanuman to a piece of kindling and light the blaze. Summoning all his resources, he bursts from his bindings and, grabbing the burning embers, leaps from one building to another, creating an inferno in Alengka, but carefully avoiding the apartments where Sita is held. Leaving the city in flames, Hanuman flies to the forest of Resiamuka, bearing Sita's letter and love token to the grateful Rama. This concludes the episode.

PART II: SUKASRANA The next part of the story, which takes place in the early evening, is called Sukasrana after one of the demons in Alengka. The play opens with a meeting at the Court of Giants in Alengka between Rawana, Wibisana (Rawana's brother), Prajangga (the Prime Minister), Dumarkasa (the Minister), Kempana (the Leader of the Security Guards), and Semali (Rawana's grandfather), who takes a major role in the gathering. The demons feel humiliated because their city was burned by one small monkey and are determined to conceive a strategy to defeat Rama.

The Prime Minister declares, "We don't need to be meeting. We need to gather equipment and supplies for fighting. Everybody knows how *sakti* [spiritually powerful] Rawana is. Let's gather our weapons and fight."

Wibisana disagrees and encourages Rawana to return Sita to her husband: "You cannot defeat Rama because he is an incarnation of the God Wisnu." This infuriates Rawana, and he banishes his brother from Alengka. Wibisana goes to the enemy camp and asks Hanuman to take him to Rama.

The next scene opens in Alengka, where Rawana commissions negotiator Sukasrana to spy on Rama's camp to determine the size and strength of his army. He also commands him to encourage the monkey King Sugriwa to defect and switch alliances. Sukasrana transforms himself into a monkey and flies to Rama's camp, where members of the army are eating. He tries to join them but is recognized by Wibisana, who sees through his disguise. Sukasrana is captured, bound, and brought to Rama, who asks the monkeys why they have tied up their brother. Wibisana tells Rama the monkey's identity and asks if he should be killed. Rama answers: "Don't kill him. Let him return and tell his king all he wants to know."

Sukasrana flies back to Rawana and tells him everything he has seen in the forest. Although this episode has little action, it takes two and a half hours to perform because the conversations are lengthy.

PART III: HANGADA KAUTUS The final presentation, Hangada Kautus, occurs late in the evening. Twalen and Merdah request an update from Rama, their master, on the current situation. Rama wishes to send a final message to Rawana, asking him to return Sita to avoid bloodshed. If the demon King refuses, Rama says he will attack. He decides to use Hangada, the red monkey, as his emissary. The scene shifts to Alengka, where Rawana's servants, Delem and Sangut, are talking about Sukasrana, agreeing that he was a complete failure as an emissary and acted stupidly. On his return to Alengka from Rama's camp, he told Rawana that Rama was powerful and possessed a large army. This made the demon King so angry that he beat Sukasrana. Sukasrana admitted his failings but was not reprieved.

Hangada, the red monkey, then enters with a message. The security guards are afraid he is another Hanuman, even though Hangada is a very small monkey. Admitted to Rawana's presence, Hangada curls his tail under himself to create a chair that makes him equal in height to Rawana, and delivers this message: "I am an emissary from Rama. Please bring Sita back. If you don't, Rama will attack your palace and kill you." At a signal from Rawana, the security guards and Rawana's two sons, Meganada and Indrajit, try to slaughter Hangada. Rama's army appears, and a huge battle ensues. The army of agile monkeys and animals challenge the army of cloddish demons. Hanuman (the white monkey), Sugriwa (the elder monkey King), and Laksmana (Rama's brother), take on Kumbakarna, the enormous, many-headed elder brother of Rawana. The seven wives of Indrajit (who are angels) fly in to aid him in his fight with Hangada. Rama and Rawana direct the battle from opposite sides of the performing area and thus ends the final two hours of the drama, the battle itself lasting ten to fifteen minutes.

RAMA

The majestic hero of the *Ramayana* epic is described as being like the moon, a bringer of light from darkness. As a reincarnation of the God Wisnu, he is devoted to truth and leads his community along the path of spiritual righteousness. Rama sets an example for his people by embodying strength, courage, love, and compassion. The refined features of his mask—the soft, gentle smile set off by perfectly even teeth, the intelligent-looking eyes, and the elegant nose—reflect his supreme grace and nobility. He is painted green, Wisnu's color, and wears the god's distinctive headdress with winged side pieces and a decorative Garuda bird, the traditional mount of Wisnu, in the back.

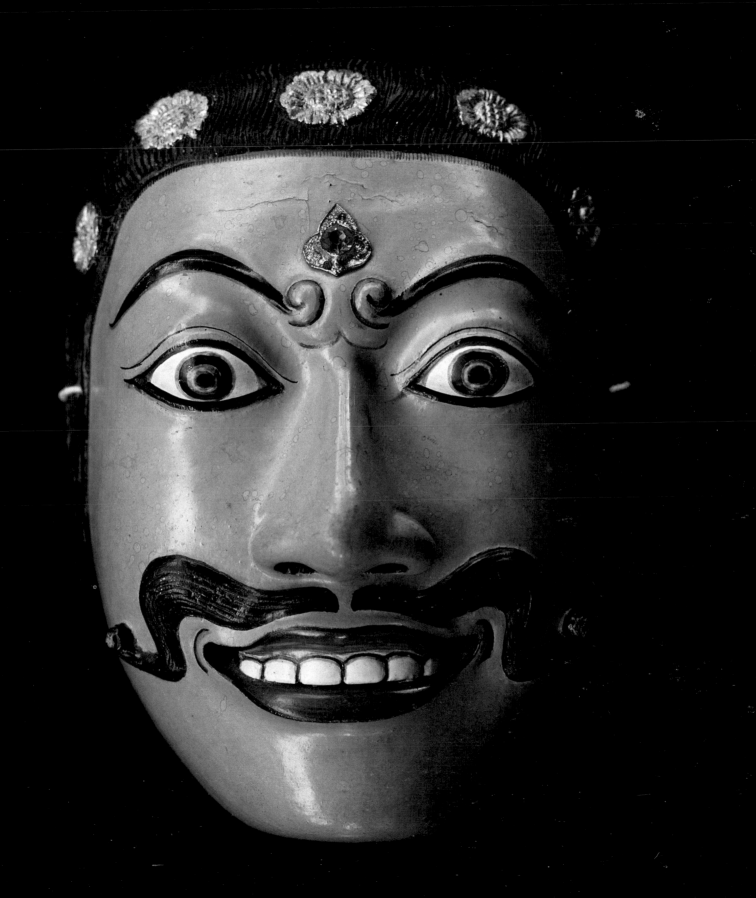

SITA

Sita is the passionate symbol of marital love and fidelity, and of perfection in a married woman. She is a worthy queen for the exalted Rama, who regards her as the most beautiful woman in the world. She is also honest, direct, strong-minded, and strong-willed. A refined character who craves order, she bravely endures the continuous assaults of Rawana, the demon King, and retains her dignity and trust in her husband.

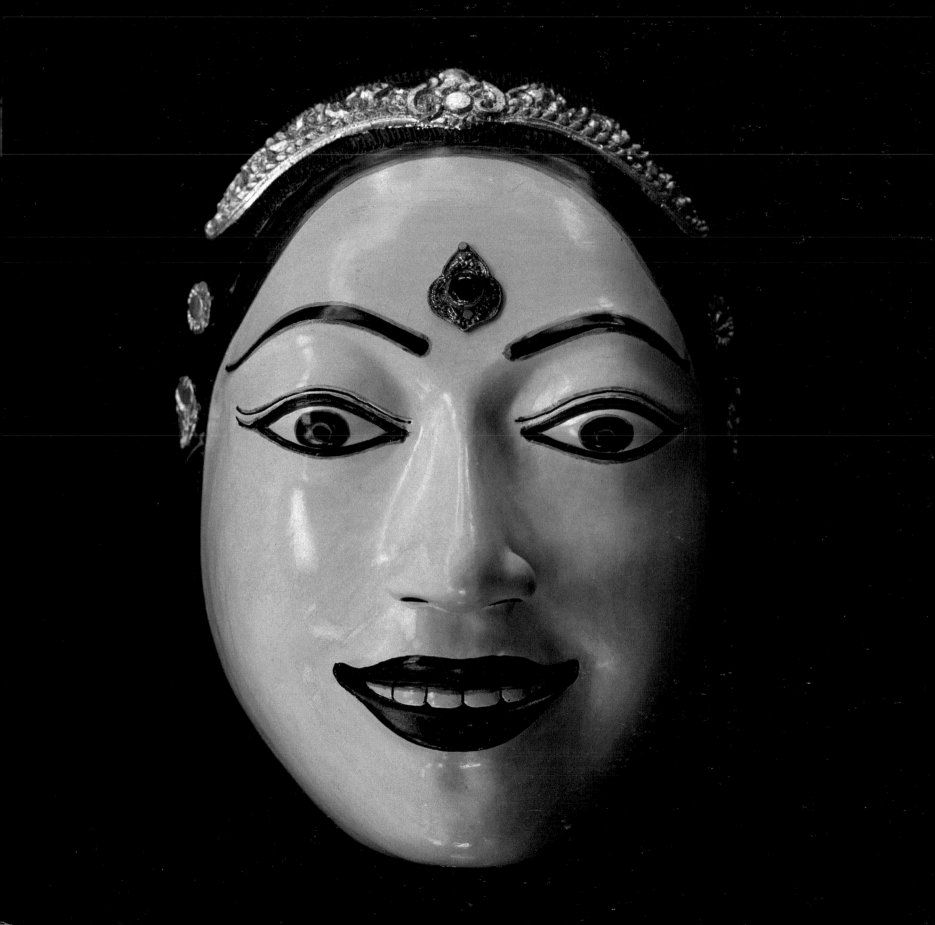

LAKSMANA

Laksmana, Rama's brother, is said to be like a star, a beautifully shaped ornament in the night which acts as a compass to give direction to the correct path. His exemplary behavior, fraternal loyalty, courage, and steadfastness make him a model for the community. The delicate features of his mask and his radiant smile are mirrored in his lithe, sure-footed, and slender physique. His traditional head-dress is crowned with a horn that curves from the base to the top of the head, an image also found in the headdress of the romantic Arjuna, an important character in the *Mahabharata* epic.

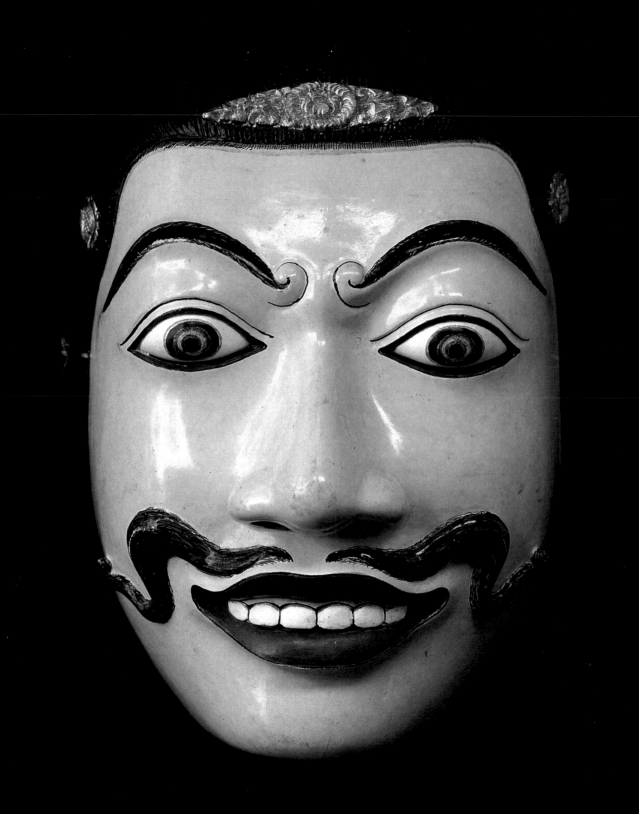

WIBISANA

Rawana's younger brother is the one voice of moderation amid the perniciousness of the Court of Giants. A free thinker, Wibisana adheres to Hindu law and is benevolent in his dealings with others. Because he is subtle and soft-spoken and because he defects to the side of the forces of the right, or the high spirits, his mask does not reflect his giant/demon birthright but reveals his soul. Wibisana's mask is white, smooth, and well defined, and is as dignified as that of Rama. Like Rama, he is a true example of someone achieving his highest potential.

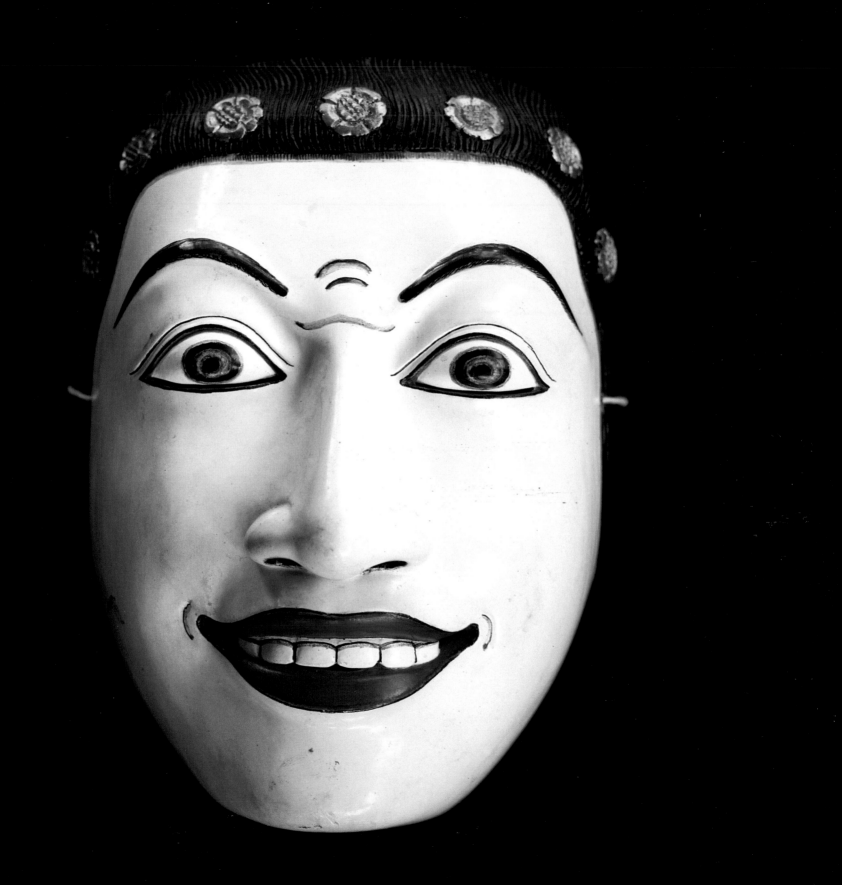

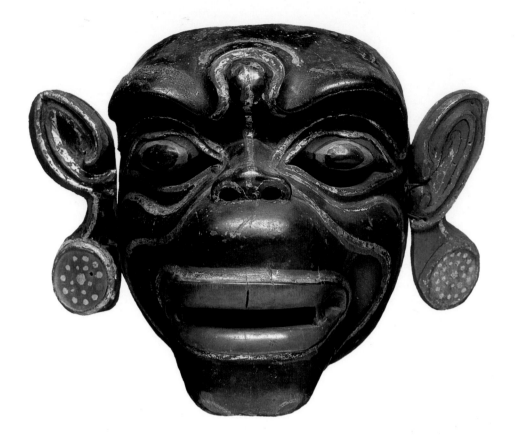

The clumsy clown/servant to Rama is actually a powerful bringer of good luck and is considered near divine. His name means "the old one." He is the son of Siwa, who created Twalen out of his own energy and sent him to earth in the guise of an honest, simple, potbellied advisor to the hero. His gray face, slightly melancholic eyes, and huge ears disguise his resourcefulness and wisdom. His body, ponderous from overeating, is weak, but he has a fine mind. Intelligent counsel as well as witty jests flow from the performer behind the hinged jaw of this mask. Although homely, with a small flat nose, animal-like muzzle, and small anemic mustache, he is a lover of women and is constantly worried about the activities of his young wife during his long absences. As translator of the story, spiritual guide, and clown, he is the audience's favorite character in the drama. *(Above)*

The honest, credulous son of Twalen, servant to Rama, serves as secretary to his father, as well as attendant to Rama, and translates the play's action to the audience. He dotes on conversations with his father, and his alert eyes betray his eagerness to absorb his father's wisdom. His quick, lean body and his fast, stiff movements are a counterpoint to his father's sluggishness. The many gilt-edged wrinkles in Merdah's forehead highlight the serious religious aspect of his personality, which is balanced by his jovial comments about food and drink, and about his desire for a girlfriend. Born without a mother, from his father's energy alone, Merdah makes a perfect complement to and foil for his father. *(Right)*

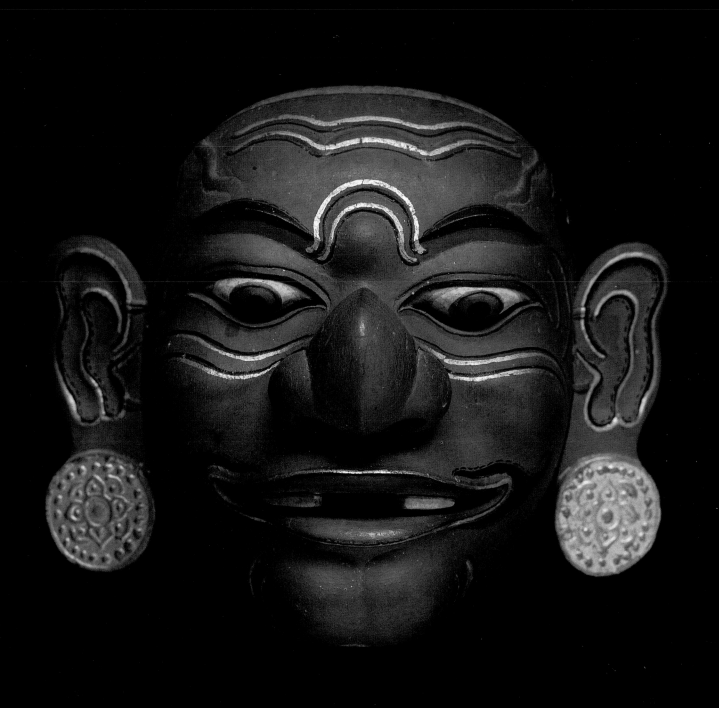

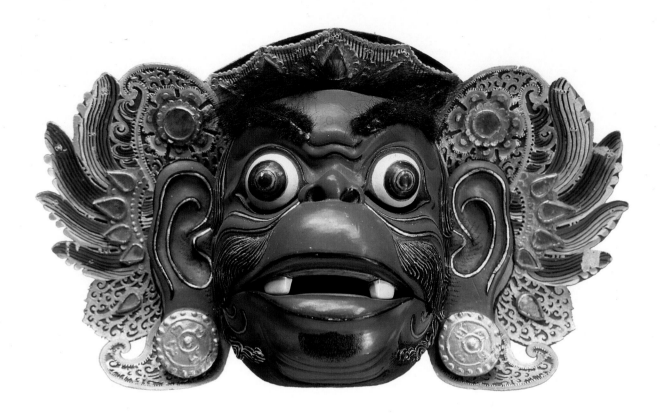

DELEM

The wild-haired Delem, servant to Rawana, is an arrogant master of self-deception and conceit. A critical frown covers his forehead, which supports woolly, bushy brows and bulging demonic eyes that disclose his dubious character. His strong voice issues from a gap-toothed muzzle devoid of an upper lip. Delem's pride is apparent in the oversized decorations that stretch his bulky ears and frame his expectant, dark brown face. As attendant to the demon King, he translates the action occurring in the Court of Giants. *(Above)*

SANGUT

The younger brother of Delem has a good heart but is compromised by loyalty to his sibling and fear of his demonic master, Rawana. His mask is one of the few unblemished by wrinkles of concern. His eyes have a quizzically surprised look that projects a contradictory, unbalanced attitude. Sangut assists Delem in translating the action of the drama. Witty remarks flow from Sangut's lipless, turtlelike mouth, which is shrouded with a small goatee. The mustard-colored little clown emerges as one of the few winners in Rawana's doomed kingdom of evil. *(Right)*

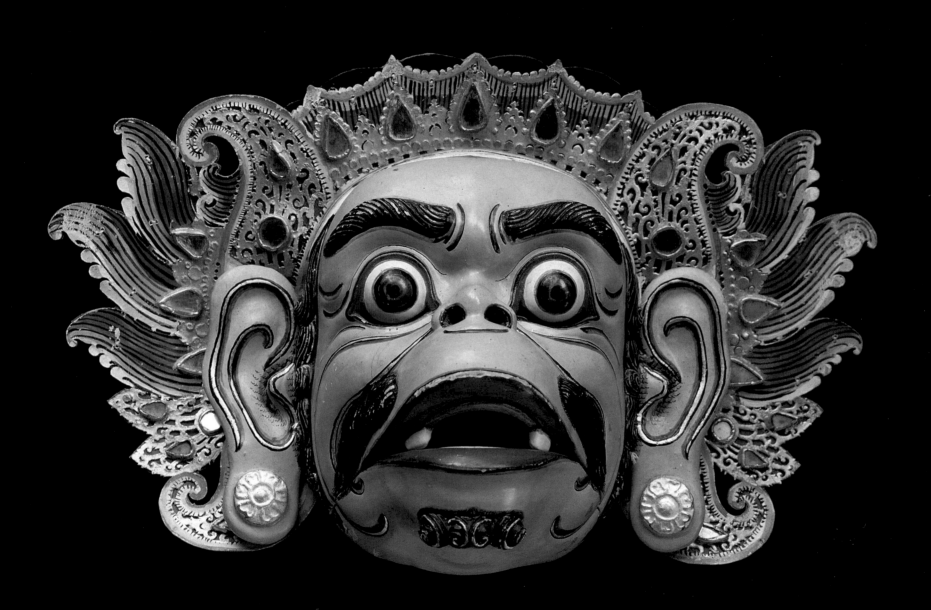

HANUMAN

The white monkey, who is of divine parentage, is the son of Bayu Wakya, God of the Wind. He can travel through the air and fill any space, large or small. This clever, courageous general of Rama's monkey army channels his tremendous strength and energy to support the causes of truth without demanding anything in return. His unselfish loyalty to Rama, his thoughtful, honest personality, and his magical powers make him a fascinating and pivotal character in the drama. Because of these qualities, his mask is more detailed, the mouth farther open, and the canines more pronounced than in other masks. Possessing tremendous agility and performing feats of daring and bravado, Hanuman is the great scene stealer of the *Ramayana*.

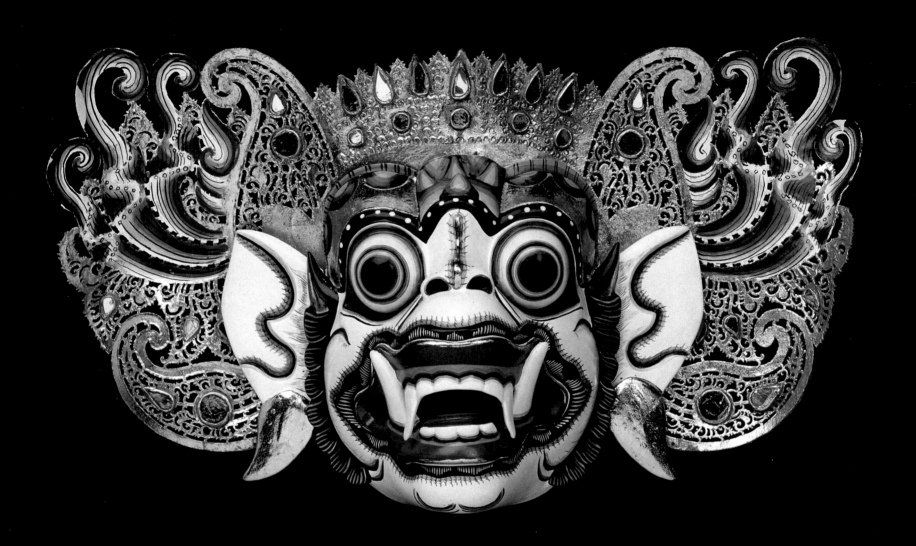

SUBALI / SUGRIWA

The twin brothers wear the same mask. Sugriwa, the younger of the rival monkey kings, is said to be like the sun; he possesses the vibrant energy necessary to the life of his army. A courageous leader, he is loyal to Rama and is willing to sacrifice himself for the sake of virtue. His heavily wrinkled face, edged in gold, that reflects his noble personality, shows he has many problems and responsibilities. His mission, to retrieve his beloved Dewi Tara, abducted by his brother, Subali, mirrors the task of Rama, who seeks to save his stolen wife, Sita. It is fitting that Sugriwa and Rama should join forces and support each other.

Subali, the unfortunate older brother of the rival monkeys, is compared to fire; everything that enters his path is burned. His power, intensely projecting from his bulging red and yellow eyes, is so strong that only a god, or an incarnation of one, can destroy him. According to the *Ramayana* legend in Bali, he is in a problematic position. Subali fought and killed the demon who lived inside the cave of Kiskenda in India. Sugriwa mistakenly believed his brother to be dead and claimed his brother's wife, Dewi Tara, as his own. Subali reappears, however, declaring Sugriwa's new wife as justly his, and the strife between the brothers begins.

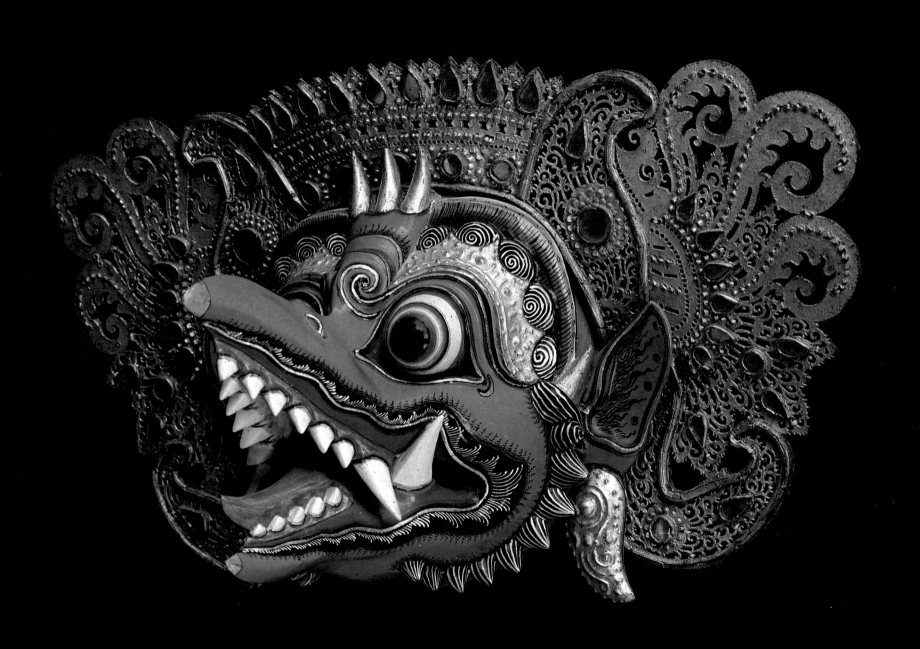

RAWANA

The proud, self-centered, lawless King of Alengka exists for his own personal convenience, and other beings live only to serve him. His bulging eyes betray his wickedness, and his blood-red lips gloat with laughter, exposing a strong overbite and cruel fangs poised for gluttonous action. He blindly follows his appetites, which are as excessive as the broad band of gold on his forehead. His grotesque features are framed by a highly defined hairline across his forehead, extending to mutton chops at the jaw and a curly black beard hugging the vicious mouth. In Indonesia, comparing someone to the odious bully is considered to be a grave insult.

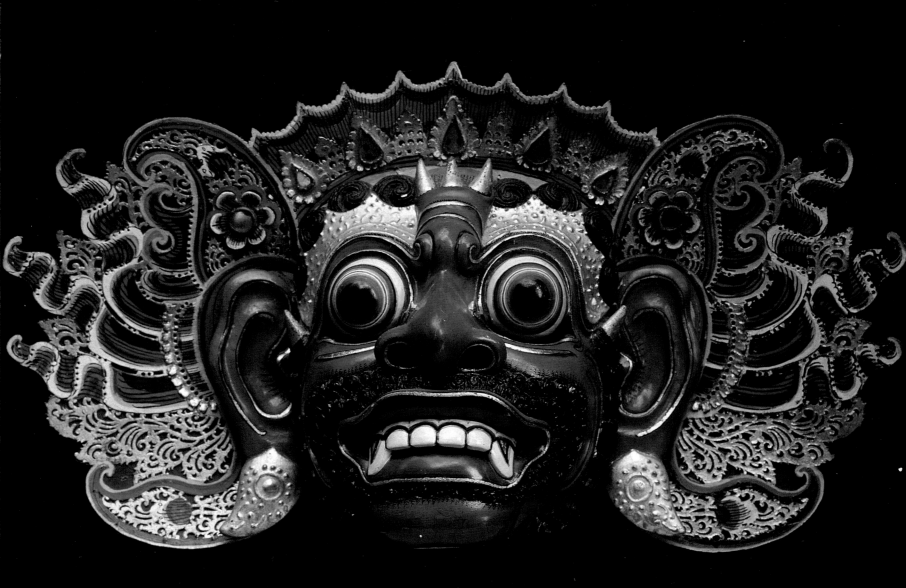

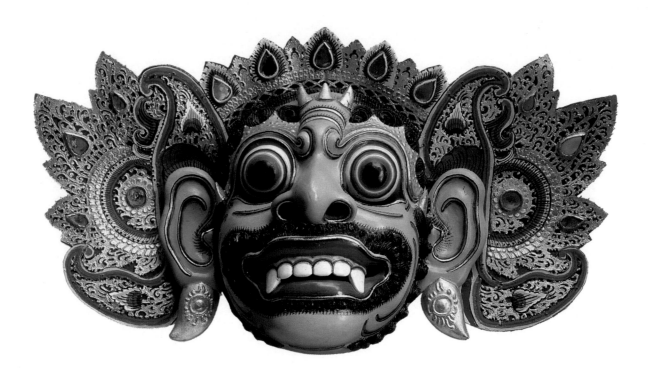

INDRAJIT

The energetic crown prince of Alengka, master of illusion, is thoroughly evil, but is not as despicable as his loathsome father, Rawana. He is committed to the triumph of evil, and as his name suggests, he could conquer the God Indra. *(Above)*

KUMBAKARNA

Everything about Rawana's younger brother, the largest of giants, is oversized. *Kumba* means "big water jug," and karna, "ears." Like his name, Kumbakarna is a figure of extremes: he is taller, heavier, lazier, and stronger than any of the other demons. His pink mask has a huge mouth, exposed gums, numerous large teeth and lower fangs, an enormous flaring nose, and red-and-white bulging eyes. Although he possesses powerful magic, he is not an outlaw by temperament and adheres to a tolerant attitude. Because Kumbakarna has a prodigious appetite for food and sleep, his name is often applied to those who have the same habits. *(Right)*

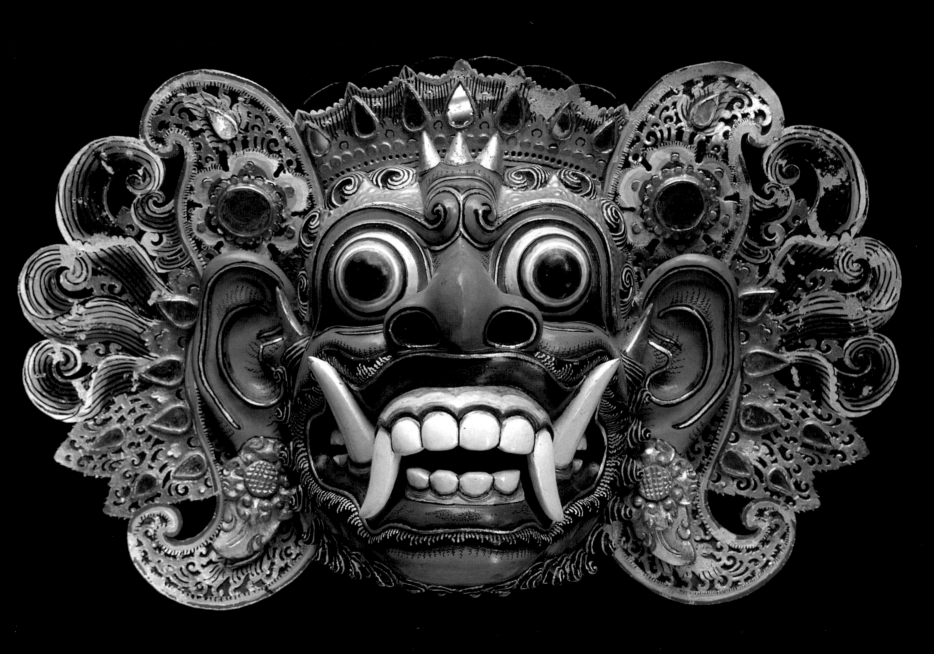

CALONARANG

Calonarang drama first appeared in fourteenth century Java, but lost importance with the expansion of Islam into Indonesia, and is very rarely performed today in Java. It gained popularity in nineteenth century Bali, and according to writers I Made Bandem and Fredrik DeBoer, Calonarang existed in Gianyar district in 1825. In the Gianyar court of I Dewa Agung Sakti, Gambuh dancers from three different villages were organized by choreographers I Sabda and I Goya to perform the Calonarang. The success of the presentation caused the drama to spread quickly to many other villages.

The Calonarang serves a variety of purposes, depending on the situation in which it is performed. The primary masked character in the drama, commonly referred to as Rangda or Calonarang, also represents Dewi Durga, the Queen of Witches and Goddess of Death, to whom the *pura dalem*, the temple of the dead in each village, is dedicated. Commemoration of the temple's birthday may occasion a performance. An outbreak of disease blamed on local practitioners of black magic may necessitate the performing of the Calonarang as a power display in which the Queen of Witches challenges local witches, or *leyaks*, to match her ability. If she is victorious, the *leyaks* must relinquish the ills that they inflicted on the village. The play also serves an educational function by using storytelling to acquaint the audience with an important part of Indonesian history. Finally, Calonarang is a form of entertainment performed solely for the enjoyment of the audience.

Dewi Durga is the opposing aspect of Dewi Uma, Goddess of Fertility and wife of Siwa. Siwa, who with Brahma and Wisnu constitutes the Hindu Trinity, is the destroyer, and Durga is an extension of his destructive aspect. In Bali, as in India, Siwa is often worshipped in the form of a lingam, the Hindu phallic symbol. Just as the cycles of death and birth are intertwined, so are Siwa and Durga. As rulers of the underworld, they represent death and decay and the germination of life, processes essential to life on earth. When the Balinese give offerings to Durga, they are not worshipping evil but are recognizing the balance between life and death in the form of Siwa. In Janger, Prembon, and Arjuna Wiwaha performances, the dancer wears the mask of Rangda in order to represent Siwa.

The Balinese people have long believed that the supernatural exists as part of daily life. More frightening, in some ways, than mischievous and rampaging spirits are human beings who have studied black magic and use it for destructive purposes. Both black magicians *(balian pangiwa)* and white magicians *(balian panengen)* can be found in Bali, especially in the south, near the coast. White magic, generally associated with healing, is administered by *balian* who concoct herbal medicines. Very powerful *balian panengan* may also control an element of nature, such as rain. Black magicians are of two kinds: individuals who study black arts that can inflict sickness, mental illness, or death, and can conjure love potions, and individuals who supply the antidote to harm. Very *sakti*, or powerful, *balian* can transform themselves into animals, objects, balls of flame, and even Rangda, Queen of Witches, herself. Almost everyone in Bali has seen a witch in some state of transformation, and many have been the victims of black magic.

Balian receive their knowledge either as a spiritual gift or by the study of ancient *lontar* books. Matah Gde, the leading character in the Calonarang drama, is said to have possessed two impressive books on magic from which she received her power. *Balian* can also pass on their knowledge in the form of medicines, amulets, belts containing pre-

scribed formulas, or white cloths bearing magic inscriptions. The performance of Calonarang is, therefore, an exorcism, a reminder that Rangda, Queen of Witches and Goddess of Death, prevents human witches from overstepping their power. In areas of Bali that are hotbeds of black magic, such as the village of Sanur, local witches must frequently be exorcised.

There are almost as many versions of the Calonarang as there are villages in Bali. The story, partially based on fact, comes from one source in Java, but has many translations, each involving its own imagery, extraneous dialogue, and plot interpretation, which gives a version its distinctive style. The title of the drama translates as "easy" *(calu),* "to eat or kill" *(arang).* According to the Javanese story, Mehendratta, a Javanese princess, had a grandson, Erlangga, who was born in Bali in A.D. 991 and grew up to become a renowned and successful ruler. By uniting Bali and Java, he saved the islands from the plagues and destruction reputedly caused by the black magic of his grandmother. In the latter part of his life, Erlangga retired to a hermitage, under the supervision of his teacher, Mpu Baradah, a holy man and the only person with enough power to destroy Calonarang.

PERFORMERS The men who perform
the Rangda role in the Calonarang drama take a dangerous risk and can be literally playing with fire. They draw to themselves the forces of black magic, not only by wearing the Rangda mask, but also by using a mantra chanted before the performance which invites the *leyak,* or witch, of the local area to do battle. If preparations are not followed in the prescribed manner, or if the power that protects the dancer is not strong, he could become ill and possibly die. Stories abound in Bali

of such situations, including the legend of a famous performer of the Rangda role who used to stop the drama and challenge any member of the audience to stab him in the stomach. One night his power failed him when an innocent volunteer drew blood and caused his death.

Because of the occupational perils, only specialists, some of whom are not trained dancers, perform the role of Rangda. They are sometimes referred to as *anak sakti,* men of power, and they are *balian,* priests, or members of families long associated with spiritual power. Some *anak sakti* are protected by family power, some by the use of personal mantras, some by personal relationships with a sacred Rangda mask, and some by a protective layer of skin that covers their bodies during performance. The dancer of Rangda does not want to go into a trance, because the spirit entering his body will not be that of the Queen of Witches but a demon aspect or a cohort of a local sorcerer who wishes to injure him.

The name *Rangda* comes from the Javanese word *ronda,* meaning "widow." The stigma that was traditionally attached to the word originated with the Hindu practice of *suttee,* which required that a wife immolate herself on the burning funeral pyre of her husband. Wives of Balinese rajas sometimes sacrificed themselves at cremation ceremonies from at least the 1400s until 1895, when the practice was outlawed by Dutch colonialists. According to one account, the first wife (rajas had many) carried a small ball with her to the cremation. She threw it, and at the point where it landed, all the wives lined up, facing east, and plunged daggers into their breasts. Any widow who ignored this practice was despised and feared by society, which believed she had absorbed the strength and power of her dead husband. Balinese women still sacrifice their hair at the cremation of their husbands, and

according to an important performer of Rangda in Bali today, any woman who has been widowed three times is believed to have accumulated enough power to perform black magic.

Rangda dancers usually perform in their own villages with the masks residing in the *pura dalem*, but as the number of *anak sakti*, or powerful men, are limited, they are often invited to perform in other villages, wearing the Rangda mask belonging to that village. Masks are very particular about who wears them. Because of these special considerations, few villages possess Calonarang companies, and actors from different villages are usually commissioned for special performances. As in other Balinese dramas, the dialogue is improvised. Since the actors specialize in certain characters, few rehearsals are necessary. The actor playing Rangda almost never rehearses. The greatest chance the actor takes is in naming practicing witches during the performance. This is done infrequently, only when the power of the dancer is strong enough to prevent him from going into trance.

Other performers in the Calonarang drama are considered specialists, and their roles, although not as potent as that of Rangda, still require special knowledge. One of these, the Dusang, the professional corpse, who does not wear a mask, remains in limp submission as all the rituals connected with death are carried out in the drama. After the conclusion of the play, the Dusang spends the night in the graveyard alone, to the horror of the local people, who believe that witches feast on the dead. In playing the deceased, the actor makes himself vulnerable to a most hideous fate. The role requires more courage than talent.

Another actor, the Pandung, Prime Minister to Erlangga, performs a dangerous role. The action of the drama requires that he stab Rangda with his *kris* (dagger). In so doing, he is also striking a goddess, thereby inviting his own destruction. Like the Topeng Pajegan dancer, the Pandung must undergo the *mewinten* purification ceremony and sometimes asks for a special charm to protect himself.

Two other important performers are the men performing Matah Gde, the role of the widow

before she is transformed into Rangda, and her female servant, the Condong. Both of these dancers must be familiar with elements of black magic and explain them during the drama. The Condong also describes antidotes for certain spells. This information is said to infuriate local witches, because it involves the revealing of trade secrets. Local witches may try to attack the two dancers prior to the revelation of such secrets or in retaliation after the conclusion of the drama.

Unless the Calonarang is performed for tourists, it is presented in or close to the cemetery of the *pura dalem* or at crossroads where a banyan tree grows, both of which are magically charged areas favored by witches and *butas* and *kalas* (low spirits). The dirt-floored performing area, or *kalangan*, is rectangular. The actors make their entrance from one side, with the exception of Rangda, who has her own bamboo house at the opposite side. The audience sits, stands, or squats in three-quarter round. A small bamboo shrine on a bamboo pole, especially constructed for the occasion and placed at the northeast corner of the stage, holds meat offerings for the *butas* and *kalas*. One or two male papaya trees are planted in the center of the dirt-floored playing area. Off to one side is the Gamelan Semar Pegulingan, the ensemble usually required for Calonarang.

THE STORY OF CALONARANG

The performance begins with an introductory dance by the Sisya, a group of student witches, who transport the audience to the mysterious land of Dirah in Java, reputedly infested with black magic. The widow of the King of Dirah, Matah Gde enters and is soon joined soon by Rarung, her chief apprentice. The widow is elated: King Erlangga wishes to marry her daughter, Ratna Manggali, and she instructs her students to prepare for the grand ceremony.

The scene changes to the Kingdom of Erlangga. The King is introduced by his servants, who may wear the masks of Penasar Kelihan and Penasar Cenikan, and speaks to them of the beautiful

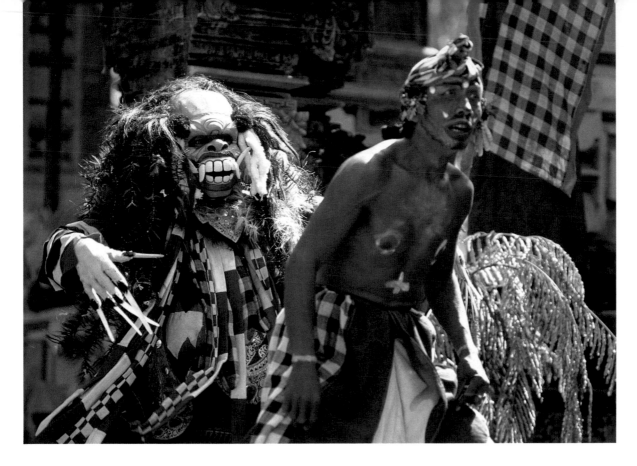

woman he recently met and whom he intends to make his wife. His mood changes when his Prime Minister, Patih Madri, tells him that his intended, Ratna Manggali, is known as a powerful practitioner of black magic, and he must cancel the wedding. He commands Patih Madri to deliver a letter to the widow of Dirah, renouncing his engagement. Patih Madri refuses to go, confessing his fear of the widow. The furious king beats the Minister, who finally acquiesces.

Patih Madri journeys to Dirah, along with the Penasar. At this point, there may be a comic episode where the humorous witch, Cululuk, teases and terrorizes the Penasar. On arrival in Dirah, Patih Madri is welcomed by the widow of Dirah, whose initially pleasant manner turns to rage when she reads his letter. Although the Patih is only the King's ambassador, her anger is overwhelming, and she barely controls her wish to devour him. Her voice shaking, she commands him to leave before she kills him. Shaken, Patih Madri, together with the Penasar, returns to Erlangga's kingdom.

In the meantime, Matah Gde, the widow, has instructed Rarung, her apprentice, to follow the trio. When she meets them on the road, the Patih at first fails to recognize her, but then senses her evil vibration. They fight, and Rarung, using her magic powers, transforms herself into a bird and pecks out the beleaguered Patih's eyes. In this scene Rarung may appear in her witch mask.

Wounded, Patih Madri returns to Erlangga and makes a report to the King. The Patih's brother, Pandung, is furious at his treatment by Matah Gde, and asks the King's permission to slay her.

The brave Pandung sets off for Dirah, finding the widow transformed into Rangda Ning Dirah, who at this time dons her mask. He challenges her, and they do battle, Pandung stabbing her until she dies. He returns to his country, believing the witch to be vanquished. Rangda's body lies motionless on the stage floor. Suddenly she begins to move, resurrected by the power of Durga, Queen of Witches. She dances in triumph with her apprentice witches, who appear masked as well, and the play is concluded.

RANGDA

In the Calonarang drama, this mask represents the archetypal angry widow, a fierce, bloodthirsty cannibal who delights in causing terror and strife. (See her role in the Barong drama as Dewi Durga.) An expert in black magic and a symbol of fear, she is the Queen of Witches who rules over other practitioners. Her movements encompass all of the mannerisms that are considered rough and crude in Balinese culture: the loud, rasping voice, wild, erratic gestures, and leaping gait. The characteristic postures of Rangda include stiff, extended arms with outstretched vibrating fingers displaying six-inch-long fingernails and hairy knuckles. Rangda leaps when she dances, the drooping breasts of the costume bouncing, and the entrails of her victims flying about her neck in abandon. She arches back, her leather tongue lolling wildly, arms stiff, palms forward, and fingers splayed in an attitude the Balinese call *kepar*. Her face, with its grotesque tusks, is framed by a blanket of hair composed of *praksok* fiber or horsehair. A large white handkerchief that she holds, contains magic drawings, serves as the wrapping for her mask after performance concludes.

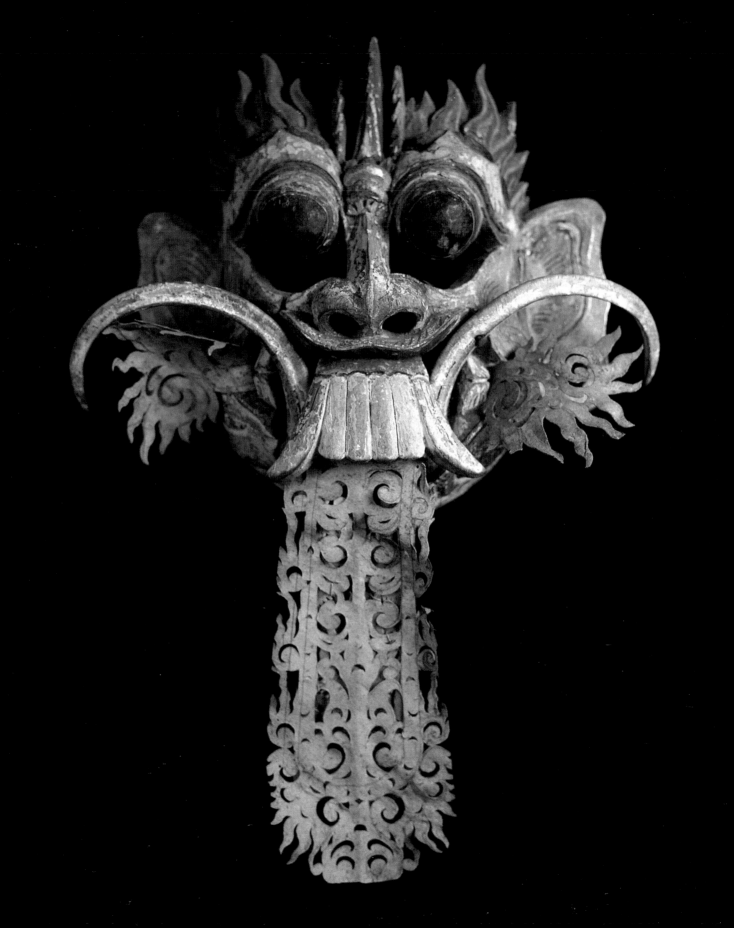

RARUNG

The chief servant of the widow and a student of black magic, Rarung first appears as a beautiful woman. In the course of the Calonarang drama, she transforms into her *leyak* state and wears her fierce mask. Her name translates as "the ability to dispose of objects," specifically dead bodies, and Rarung possesses the power that allows the ashes of the dead to be absorbed by the sea. Her eyes are regarded as bulging hot like fire. She was originally created from human blood, and can transform herself into a tiger.

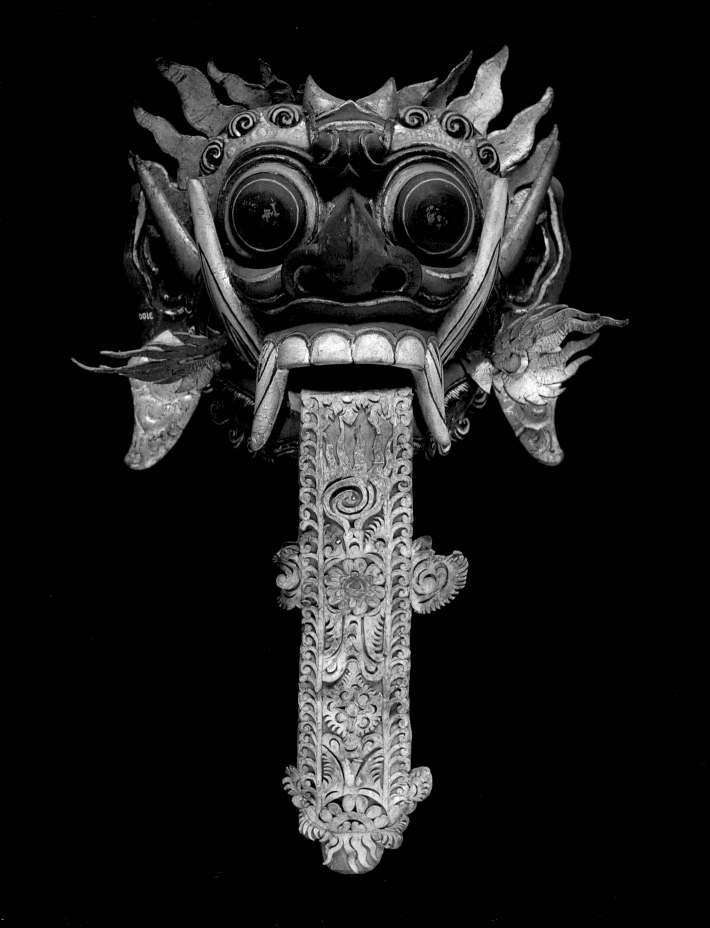

JARAN GUYANG

This powerful witch is able to transform her essence into assorted shapes and images, most notably a horse. The character's name literally translates as "a horse whinnying on the ground." The squinting eyes and twisted mouth of the mask are carved to reflect the horse's whinny. Easily jealous and quarrelsome, she is especially proficient at conjuring spells that cause humans to shriek and cry. Her tongue of flames, made of tooled buffalo hide, symbolizes her intense energy. In Balinese astrology, a horse is characterized as a strong, fiesty, and independent personality that is difficult to satisfy.

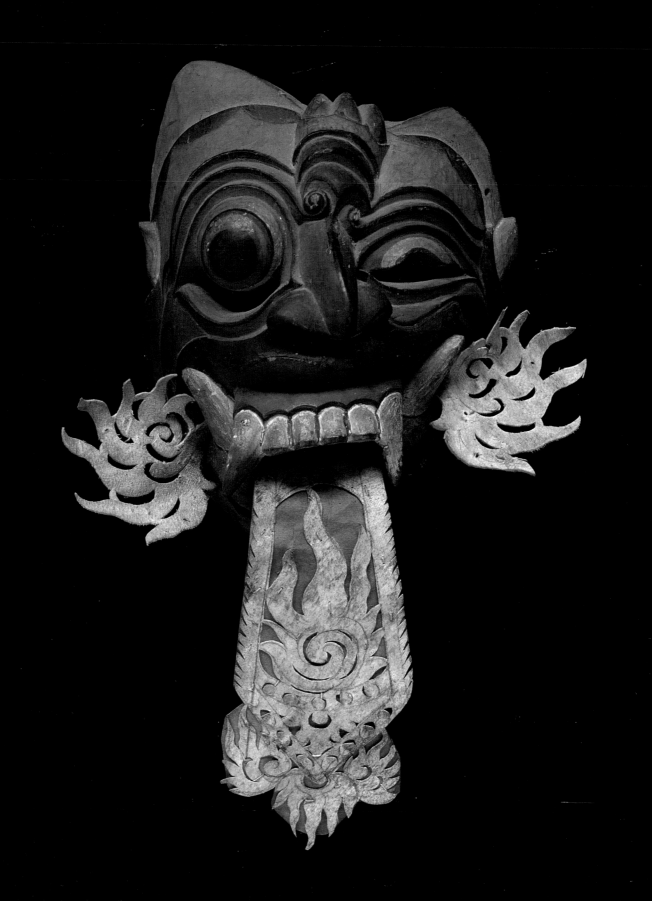

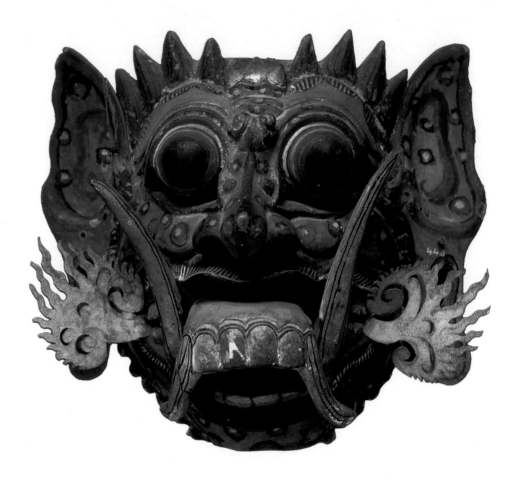

LEYAK POLENG

Poleng refers to the multihued color of this mask, which encompasses all shades. In Balinese symbology, Leyak Poleng is associated with the "middle" direction and with Siwa, the Destroyer, from whom she derives her power. Her specialty is causing plagues, and if summoned, she arrives from and departs to what is called the central direction. The word *poleng* also refers to the black-and-white-checked cloth commonly used in Bali to apron statues and religious implements. The name represents balance and harmony, yin and yang, right and left, and male and female principles. Fierce, extended canines and enlarged teeth, like those carved on this witch mask, are symbols of our animal nature and its base qualities. *(Above)*

LEYAK MATA BESIK

The one-eyed witch is also a student of black magic. Recipes for amulets and magic formulas are inscribed in *lontar*, the Balinese books made of cured palm leaves. The practice of black magic requires years devoted to the study of these books, under the supervision of an expert practitioner, in Mata Besik's case, her mistress Rangda, or Calonarang. *(Right)*

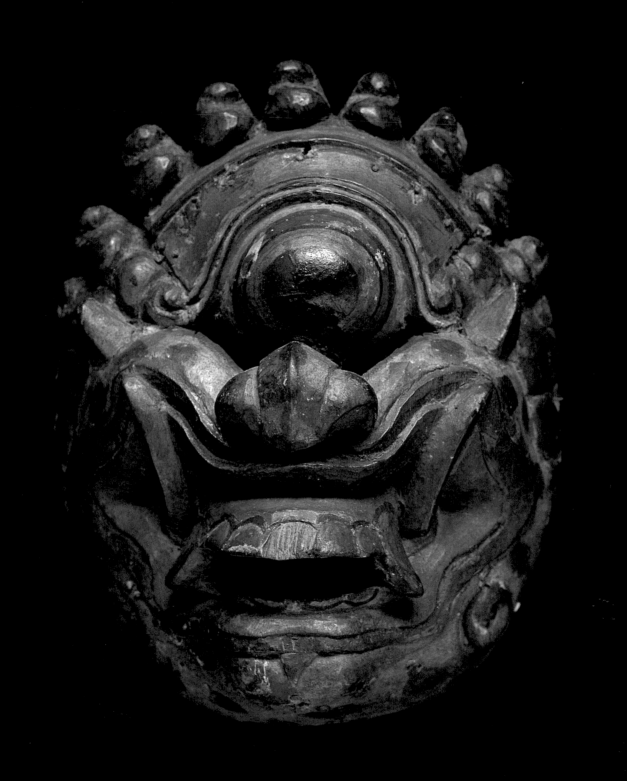

LEYAK BARAK

This apprentice witch receives her power directly from the God Brahma, a manifestation of the Supreme God and known as the creator of all living things. Barak (meaning red), is also called Leyak Merah, the color associated with Brahma and the south, or "seaward," direction. If summoned, Barak always arrives and departs from the south, which is associated with violent upheavals—storms, plagues, and strife. In traditional Balinese family compounds, the pig sty and trash heaps are confined to the southernmost corners of the compound. Her color, red, symbolizes coarse and rough characters, and is represented in Balinese offerings to low spirits with the blood of animal sacrifices. To repel Barak's attack, her name and symbols must be identified, and she must be given an offering with specific ingredients, and encouraged to return to the south.

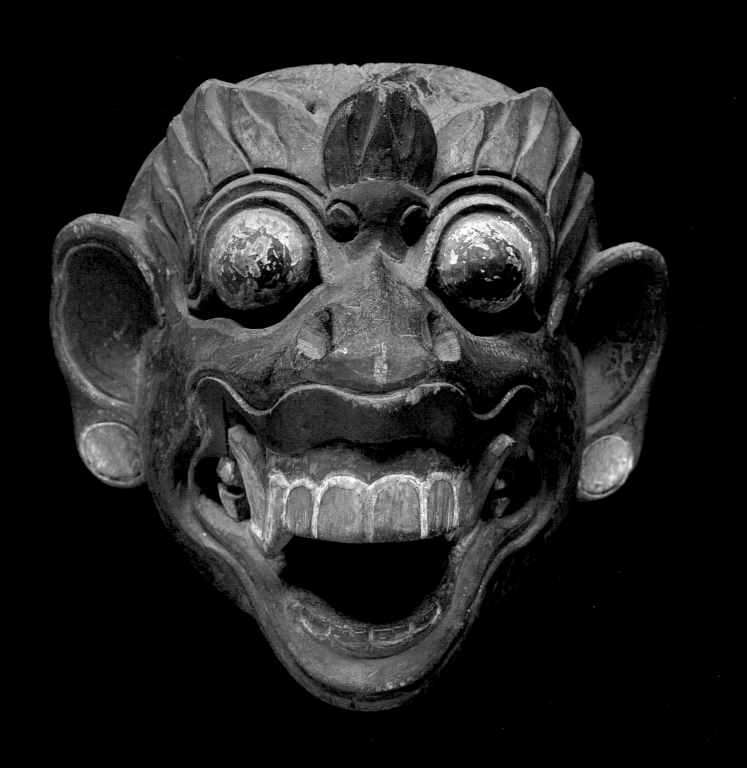

MAHISA WEDANA

Originally created from a human umbilical cord, Mahisa Wedana is a powerful witch who manifests as a white water buffalo, and a Barong, or protective spirit, with the face of a *kala*, or low spirit. The only sound she makes when she moves is the flapping of her large ears. One known means of resisting her magic is lengthy meditation at night, in the *pura dalem*, the temple of the dead, close to the cemetery. This path is only for the courageous, and is dangerous because it is also the process one follows to study black magic.

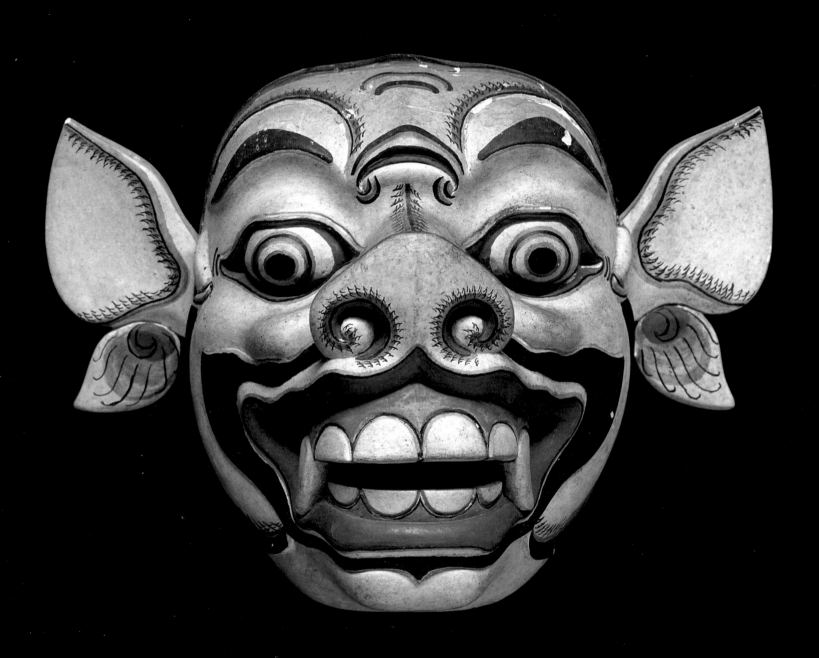

NI LENDA LENDI

Lenda Lendi, who was created from a shadow, is a worshipper of Dewi Durga, Goddess of Death and practitioner of black magic. Like her sister *leyaks,* she can transform herself into many different shapes and images, including monkeys, balls of flame, and flying white fabric, but her specialty is a crow. She moves quickly, with a scurrying gait, stopping occasionally to turn round three times, a ritualistic gesture that helps her gather power. Her mask should be carved with "happy" eyes. Like her sisters, she can cause pestilence, disease, and death, and can only be destroyed with powerful magic. Her bulging eyes are typical of witch masks.

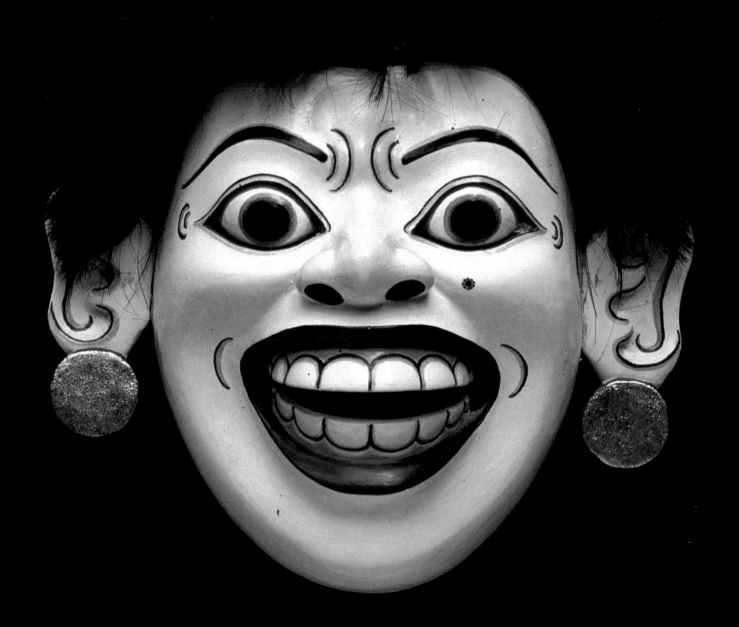

CULULUK

A recent addition to the company of witches, Cululuk is the only *leyak* who can be called comic. She appears in scenes with the Penasar, alternately frightening them and being frightened by them. The open eyes and movable jaw of the mask allow the performer to convey a variety of expressions. The bald leather head and large buck teeth and the disproportionately large stomach created by the costume make the character look more foolish than fearful. Cululuk moves with a swayback and bobbing gait, stomach thrust forward, fingers extended, and eyes peering about maliciously. The scalp is leather, and the hair *praksok* or horsehair.

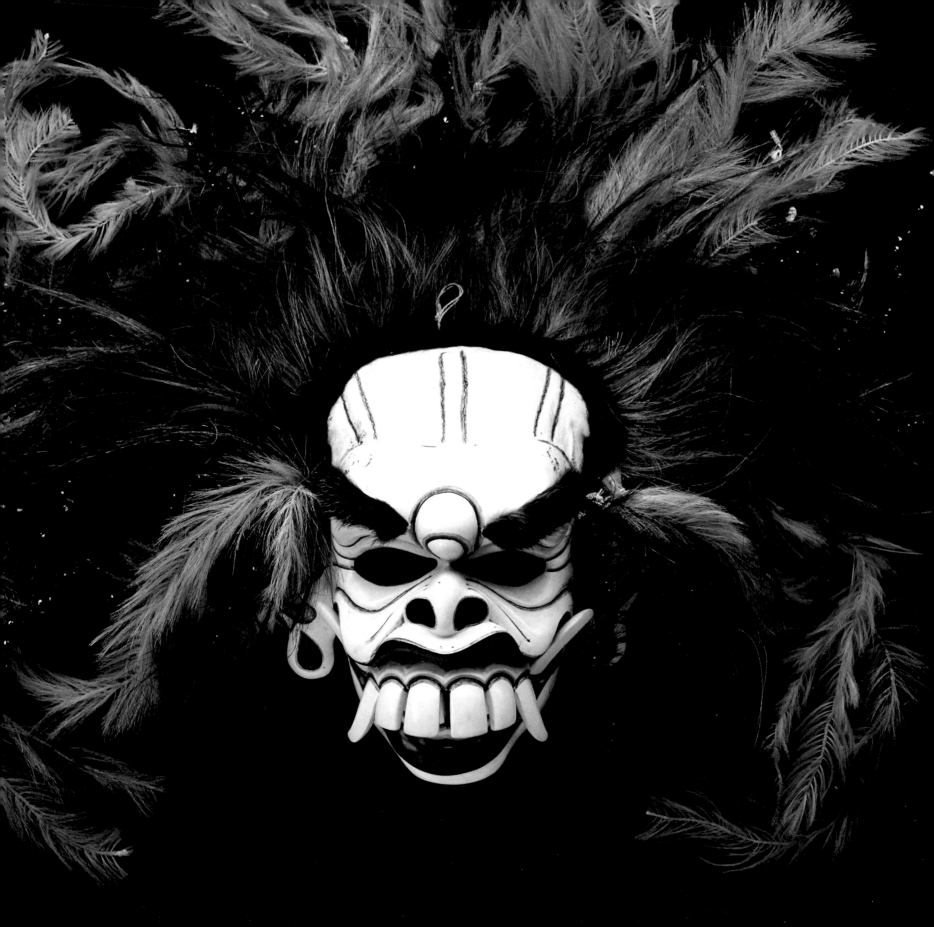

BARONG

The sacred Barong masks are among the most important masks in Bali, and the mask and costume are also the most difficult and costly to make. Rooted in ancient animism, the Barong function as protective spirits for Balinese villages. Most figures are animals, performed by two people, one wearing the mask, the other wearing the costume. The most important is the Barong Ket. Another type of Barong are Barong Landung, giant puppets wearing masks and operated by a single performer.

The origins of the Barongs, though obscure, are explained by a collection of fascinating stories, each with an entirely different perspective. Many societies acknowledge the existence of animal spirits, from whom they seek protection. The people of these societies may also identify their origins with an animal, or may believe that an animal was aided in some way by their ancestors and in gratitude has agreed to protect future generations. The animistic religion that might have preceded Bali Hinduism probably involved a variety of such creatures, which eventually formed the stable of Barong characters. Although the origin of the word *Barong* is uncertain, it may have evolved from *beruang*, Indonesian for "bear." Since bears are not indigenous to Bali, they are considered mythological.

The function of the Barong characters is to patrol the borders of the village, sniffing out and repelling demons, at specific auspicious times. This takes the form of a high-spirited procession, which often culminates at the river or sea, driving the *butas* and *kalas*, low spirits, back to their home. The Barong masks and sometimes the entire costume also appear on temple altars and during temple festivals are heaped high with offerings and incense, inviting the villagers to pray to them. Occasionally Barong appear in a drama, such as Japatuan, Basur (similar to Calonarang), or Kunti Sraya (also known as the Barong Dance).

Barong Ket, Lord of the Jungle and the most important of the Barong characters, is a symbol of the forces of the right, white magic, and male energy, and also fulfills the function of an exorcist. Plague in a village is believed to be controlled by holy water, in which the Barong's magical beard has been dipped. Living in the village of Singapadu, in central Bali, is a Barong whose eyes sometimes weep a medicinal oil. Over fifteen days, the oil is collected in jars and is dispensed to villagers with skin problems, such as eczema.

The struggle between good and evil that is dramatized by the Barong Ket and Rangda, who represents the Goddess of Death, is universal, but it is simplistic to assume that the Barong is entirely good, just as it is to believe Rangda is evil incarnate. The Barong has a dark side in his relationship to the cemetery, and some Balinese believe he is actually one aspect of Rangda.

DEMONS According to the beliefs of Bali Hinduism, good and evil exist in all things. Since evil cannot be destroyed, it must be appeased and brought under control. Balinese hold cockfights, make *caru* (offerings containing meat and placed on the ground), and hold special dramas and ceremonies, all in an attempt to placate demons, who possess power intermediate between humans and gods, and who are also manifestations of the Supreme God, Sanghyang Widhi Wasa.

The retinue of the Barong Ket and Rangda, the guardians of a village, consists of the boisterous demons of Bali. Although capable of evil mischief, they can also be enlisted as supportive influences. At village entrances, temple gates, family homes, and dangerous crossroads, statues of scowling demons brandishing clubs guard against their own kind.

Demons are commonly referred to as *butas* and *kalas*, or sometimes as *butakalas*. *Buta* (also *bhuta* or *bota*) is Sanskrit for "element" and Balinese for "blind." *Kala* means "time," specifically *sakti*, or powerful, time, which occurs at sunrise and sunset, the transition between day and night.

Demons are wild-eyed, uncouth, fanged, hairy, and generally unattractive, but are beautifully or humorously dressed. Although demons are essentially positive forces, they react emotionally and irrationally, and can become negative and destructive if not recognized and appeased. Because they are troublesome, they are not invited into all areas of the village, especially temples.

TRANCE The followers of the Barong Ket, who form his army, are called the *pangurek*. These men, who do not wear masks, emerge near the conclusion of the drama during the battle between the Barong Ket and Rangda and attack the witch with their *krisses*, or daggers. Rangda, using her magic white cloth, forces them to turn their weapons upon themselves, and they violently stab themselves, their faces contorted in agony. The godly power of the Barong protects them, and however energetically they struggle to wound themselves, the blades do not enter their bodies.

In several Balinese villages, Pangurek dancers also play a part in trance rituals involving Barong and Rangda masks. In Kesiman, a *banjar* in Denpasar, several processions of dancers wearing Barong and Rangda masks arrive at the *odalan*, the birthday festival of the Pura Petilan Pengere-bangan. After offerings are made, some of the young men in the procession become possessed by deities who render them invulnerable to harm. The possessed illustrate this power in self-stab-bing, called *ngurek*. The Barong and Rangda

dancers and the priests in the procession may also go into trance.

Bystanders, especially priests, sometimes fall into a sympathetic trance, demand a *kris*, and join the frenzy of self-stabbing. Women are also known to practice *ngurek*, though not as commonly as men. Dancers are brought out of trance by the Barong Ket, who marches around them, clacking his teeth and brushing the *pangurek* with his beard, and by priests who splash holy water on the heads of the entranced. It is unusual for *pangurek* dancers to be injured, but they are closely watched and protected by friends.

Those people who experience trance, voluntarily or not, perform an important function in drama and in the community. Through the ritual of trance, they establish a link between the everyday world and the divine, their bodies becoming vessels for ancestors, gods and goddesses, or spirits. If the invading deity decides to communicate, he or she might convey the need to introduce a new custom, performance, or mask into the community. Most of the sacred masks in Bali were created at the express wish of gods speaking through a person in a trance.

Priests most commonly experience trance, having already established a link with the spiritual world. Dancers, musicians, and *dalangs*, or shadow pup-peteers, in their priestly functions, are vulnerable to trance, and a spectator may even go into spon-taneous trance during a ceremony. As in Kesiman, the village in Denpasar, other people are occasion-ally summoned into a trance. Most seem to be people who reside in towns or villages that are not far from the ocean.

Those in trance are unable to refuse the pres-ence of the invading spirit. A male ancestor may choose to speak through a priestess, for example, or the spirit of Rangda may invade dancers per-

forming the Barong. Observers recognize the spirit by the characteristic movement and expressions, as well as by the types of offerings demanded. Offerings of blood or demands for a live chicken (whose head is chewed off by the person in trance) indicate possession by a demon. If black magic is involved in trance, sweat appears as balls of flame. Trance can induce erratic behavior, as when people run wildly through villages, cemeteries, or forests. Tests of an individual's ability to divorce himself or herself from the physical world and accept the presence of the divine include walking or bathing in burning coconut husks or coals or eating glass, as well as the more common practice of self-stabbing.

BARONG BRUTUK

Barong Brutuk, another form of the Barong mask drama, is a rarely performed ritual held only in the Bali Aga, or aboriginal, village of Trunyan, located on the shores of Lake Batur. The Bali Aga call themselves the "original Balinese," meaning those who were on the island before the Majapahit migration from Java began in 1340. The Brutuk is held irregularly, in a cycle of about every seven to ten years. Any situation that is considered unclean (death, disease, etc.) may cause the ritual to be canceled, hence its sporadic scheduling. As with other Barong, the purpose of Barong Brutuk is to control the low spirits.

Twenty-one masks are used in the drama, though not all of them may be worn during a particular performance. Only young unmarried men who are in excellent health may participate. Dancers are secluded for a forty-two day period prior to performance, during which they gather banana leaves for their costumes, which resemble aprons.

The performance, which lasts an entire day, centers on the King and Queen, I Dewa Pancering Jagat and I Dewa Ayu Pingit. The remaining performers play their followers, the female characters wearing white and yellow masks and the male wearing red and brown. The masks, which are rather crude with little definition of features and detail, resemble the coconut shell masks found in the Museum Bali, the anthropological museum in Denpasar.

The dancers enter the performing area wearing their bulbous banana-leaf costumes. Brandishing twelve-foot-long whips, they mercilessly thrash at anyone who dares come too close. Their purpose seems to be to snatch a piece of the King's and Queen's costumes, which have magical properties. After hours of frenzied thrashing, the ceremony culminates in a courtship dance between the King and Queen.

PROCESSION

The Barong procession is endowed with religious and ritualistic significance. Each element dramatizes aspects important to the occasion. Many Barong processions begin with young boys carrying *tebu*, stalks of sugar cane, as a preamble of what is to come. The outside of the *tebu* is hard but inside lies a sweet surprise. Like the human body, the exterior should be strong, and the interior should contain a sweet heart.

The next elements (sometimes the first) in a procession are the *umbul*, bamboo poles bearing elongated cotton banners with narrow streamer-like tails. They symbolize the sacred mountain, home of the deities. The *umbul* are often painted with the image of Besukih, the dragon who lives at the base of Bali's holiest volcano, Gunung Agung.

Several groups of men and boys appear next. The first usually bears circular shields made of rattan and bamboo, which protect the village. Those who follow carry lances, short spears, and maces, and make up a regiment supporting the Barong Ket in the battle between good and evil.

Then come the carriers of the *pajeng*, colorful fringed cotton parasols symbolizing the importance of the sacred masks and protecting them from possible impurities. When the procession arrives at the temple, the parasols are placed with the masks in the shrine. Following close behind are the bearers of the white cotton flags called *kober*, which are decorated with black ink drawings of magic symbols and large drawings of mythological animals related to the air, such as Hanuman, the white monkey of the *Ramayana* epic, and the Garuda bird, associated with the God Wisnu. They symbolize the strength and power of the wind.

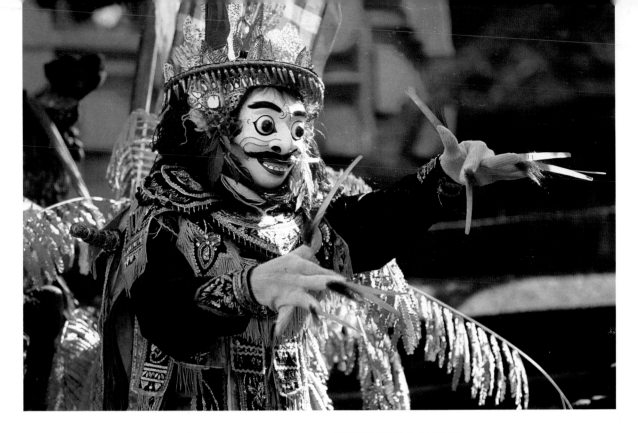

The most impressive visual spectacle comes next, in the form of women carrying offerings. Marching in single file, they are usually dressed alike, in beautifully dignified traditional sarongs and temple scarves. Some women bear towering offerings of fruit and rice cakes on their heads, testimonials to the earth and its abundance.

The Gamelan Bebonangan follows, cymbals crashing and drums beating. The lively and enthusiastic sounds draw attention to the spectacle. The musicians, dressed in identical costumes, carry their instruments in their hands or on bamboo poles. The exhilarating energy of the music calls forth the rhythms of the earth.

The Barong Ket or another Barong appears near the end of the procession, followed by a retinue of scattered villagers. The performer holding the mask and the performer wearing the costume generally walk, and present an elaborate dance only when the procession stops. In order to see better, the performer in front often holds the mask toward the sky. Despite the character's lack of animation, the sheer opulence of the costume and the riveting intensity of the mask indicate that the focal point of the procession is in the persona of the Barong.

PERFORMERS Although not considered as dangerous to perform as the character of Rangda, a sacred Barong is only animated by dancers who are specially trained and purified. Called *lawangan tandakan,* they are chosen to operate the Barong through a special vision. The perilous aspect of dancing the Barong lies in the possibility of trance, which sometimes results in physical or spiritual injury. Elaborate precautions are taken to avoid this, through offerings and prayers made in the *pura dalem* prior to performance.

Barong dancers who go into a trance run uncontrolled in the performance space, asking for *brem* (rice wine) and *arak* (liquor) or fruit. The dancers might also collapse, but whatever form the trance follows, it always overtakes both dancers enacting a Barong.

The movement of the Barong is based on the Baris, the dance of the warriors, which is generally studied by young people as a prelude to learning all other dances. The two performers enlivening the Barong, who are able to change positions, spend many hours rehearsing the precision required to coordinate the movement between the front performer's legs and the back performer's legs. The

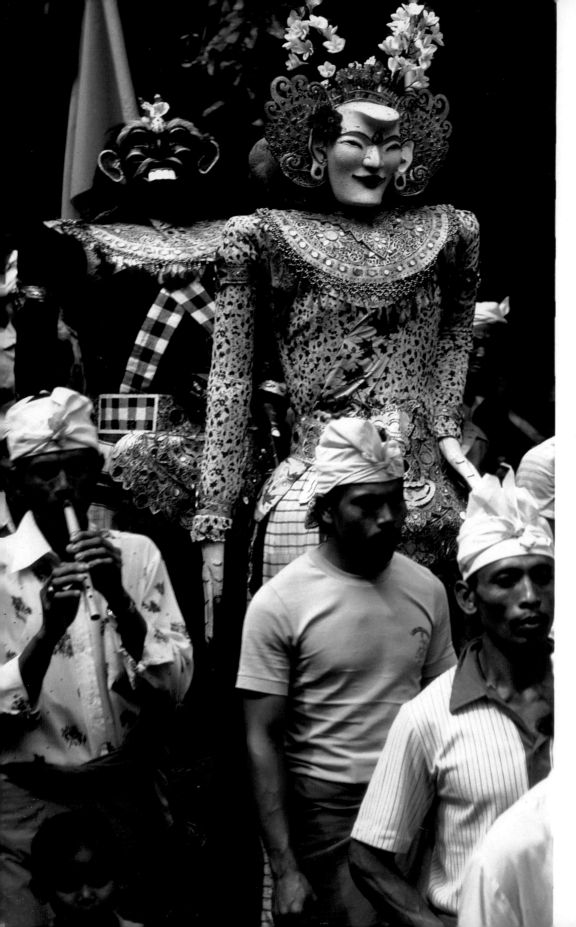

dancer in the front has by far the more demanding task, not only because he must peer through the maze of hair, decorations, and tiny slits in the mask to determine the direction of the movement, but also because he must carry and motivate the large cumbersome mask and frame to convey a variety of expressions and attitudes.

ORIGINS OF THE MASKS
A popular story among contemporary Balinese concerning the origins of the Barong Ket credits the ruler of Singapadu, Cokorda Gde Api, with creating the original Barong Ket mask about one hundred years ago. According to his grandson, Cokorda Raka Tisnu, who is one of the few carvers of sacred Barong on the island today, the chief of Srongga village went to Cokorda Api, then a young carver, and asked him to come to Srongga and create a mask with the likeness of Banaspati Raja, Lord of the Forest. Cokorda Api was given consecrated wood with which to carve the mask, and was allowed to live and work within the *pura dalem* for one month. Cokorda Api was a very spiritual man committed to the Hindu gods. He did not know what Banaspati Raja looked like, so he meditated, accompanied by the temple priest, who was his companion, and asked Siwa, the god of the temple, to send him a vision of the mask's persona. Soon after, a pale, translucent, cloudlike image appeared, and Cokorda Api dutifully re-created it with a stick on the earthen floor of the temple. It became the prototype for hundreds of Barong masks he carved in the following years.

The Balinese believe that human beings have four spiritual "siblings" that emerge at birth. They consist of Anggapati (the birth water), Prajapati (the birth blood), Banaspati (the prenatal cord), and Banaspati Raja (the placenta). These siblings may be called upon for assistance during one's lifetime. The latter, Banaspati Raja, is also Lord of the Forest (or Jungle), and is considered one of the aspects of the God Siwa. Banaspati Raja's soul is manifested in the Barong Ket, and therein lies his role as the most important protector of the Balinese.

Those familiar with masks of Asian cultures

may note the similarity of the Barong Ket to the Chinese lion and Japanese dragon masks, though the Barong is more likely linked to traditional Buddhist images. Like the Barong Ket, the Chinese lion is also connected with rituals of exorcism. The Japanese *bugaku* dragon exhibits a similar range of emotions and has a personality parallel to that of the Barong Ket. The intermingling of influences is not surprising. Buddhism and Hinduism blended for a time, and Buddhist priests are still part of Bali Hindu religious ceremonies. A sizable Chinese community exists in Bali, and Chinese coins, the recognized currency until recently, are important parts of temple offerings.

Barong Ket is also similar to Bhoma, the powerful protective image whose face appears in Bali temple entrances as a threat to unwanted guests. Bhoma is seen as well on cremation towers, the location where his image was originally used. According to this story, god Siwa was meditating when his focus was disturbed by the demon Raksasa Rahu, who delighted in teasing him. Siwa was furious, and from the energy of his third eye he created a being called Kala Kirti Muka, a personification of Siwa's power, who was ordered to kill Raksasa Rahu. The terrified demon Rahu begged Siwa's pardon, which the god accepted. Acting swiftly, Siwa ordered the power to destroy itself and the obedient Kala Kirti Muka did—except for its head. Pleased to see his order followed so thoroughly, Siwa ordained that the face of Kala Kirti Muka, known also as Bhoma, appear on every temple.

The Barong Landung consist of at least two characters. The primary ones are the male, Jero Gde, and the female, Jero Luh. *Jero* refers to a person of low caste occupying a high position. *Gde* means "royal person," and *Luh* translates as "female person." Several different legends are connected with the origin of the two Barong Landung. Each myth partially explains the unique appearance and function of these wonderful characters. One ingenious folk tale claims that the Barong Landung are the original parents of the lithesome Balinese people, the Indo-Chinese who once populated the islands of Indonesia. Jero Gde represents the dark-skinned Indian race, and Jero Luh, the fairer Chinese. Their mixed-race descendants came to inhabit the lush, fertile island of Bali.

The second legend concerns the evil giant Jero Gde Mecaling, who once inhabited the barren Indonesian island of Nusa Penida, south of Bali. Long ago, he invaded Bali, accompanied by a hoard of demons who proceeded to wreak havoc and death on their tranquil neighbors. The anxious villagers consulted a powerful priest, who told them they must create a huge likeness of the horrendous demon to frighten him away. This explains the alarming appearance of Jero Gde Mecaling (*mecaling* means "having tusks") as well as the abundance of Barong Landung masks found in the southern part of Bali, close to Nusa Penida.

The third source of information concerning the identity of the striking pair is found in the themes of the short, whimsical dramas they sometimes enact. In stories drawn from the Panji cycles of Java or from the Calonarang story, they play the lively Penasar, ribald servants to the high-born characters. They are accompanied by puppets who represent the high-born love interest of the plot and whose refinement is enhanced by their delicate appearance.

Still another legend claims that in ages past, a Balinese demon king from the tropical forest of Blingkang in Bali wanted to marry a woman from China. Surprisingly, he received her parents' permission, and as part of her dowry, she introduced delicious spices to the Balinese cuisine, including garlic, ginger, onion, and other savories.

BARONG LANDUNG PUPPETS

The Barong Landung are sacred, and traditions vary in the village temples that possess each of the puppets. The Barong Landung might be stored in peaceful temple homes for many years, awaiting an auspicious signal from the priest that their protective influence is needed. They also may be pressed into service regularly for vibrant rituals that would be incomplete without them. The Barong Landung puppets can be exhibited, surrounded by dazzling offerings and fragrant incense in a bustling, animated temple during the temple's

birthday celebration. In addition, they can be the focus of a small, modest village procession called *ngelawang*.

Barong Landung can also be the center of attention at one of the large Barong processions that includes marching gamelan musicians, chanting women with graceful decorative offerings delicately balanced on their heads, boys carrying fringed ceremonial banners, tasseled spears, and gilded temple icons, and other members of the village *banjar*, dressed in their finest embroidered temple clothing. These processions proceed to the sea for purification ceremonies, at which the benevolently smiling puppets preside over praying villagers from specially constructed bamboo alters. The *banjar* may request a performance with dialogue, but when a procession is held, a family on the route may beg the puppets to stop and present a portion of their entertaining drama as a means of keeping evil spirits from a household. If the family is successful in soliciting a performance, they must make a special offering for the occasion, called *labahan* or *segehan*, and give a donation to the temple home of the puppets. All these occasions occur in conjunction with the holy days of Galungan and Kuningan. During this time the gods and deified ancestors visit the homes of their descendants to take part in celebrating the birthday anniversary of the world.

Preparation for including the special magic of the Barong Landung in a ceremony or procession begins when the head of the *banjar* decides who will perform the roles and carry their bamboo skeleton-frame forms. If the masks are very sacred, only certain people will dare to be the actors; however, the performers need not be priests or consecrated people because the drama will not take place inside the temple. If the masks have been created because of a directive by the gods, people who perform the roles must undergo a special ceremony before their appearance. Prior to a procession, the puppets are removed from their homes, cleaned, and decorated with flowers.

Inside each puppet is a rattan apparatus which sits on the actor's shoulders and determines the range of movement of the body. The head of the puppet is turned by a pole attached to the inside of the head, which the actor holds in front of him. One arm of the puppet swings freely, and the skirt of the large costume covers the actor's legs, leaving his contrastingly minute feet exposed. Before the procession begins, the two Barong Landung appear at the gate of the temple, where the priest makes special prayers and offerings to them. Over the puppets, attendants hold parasols, which may be rigged so that they gradually sprinkle holy water over the heads of the sacred couple and those lucky enough to stand close to them. This water is believed to have special properties that can heal the sick.

The warm-hearted domestic comedy enacted by the couple mirrors human relationships, and the task of the performers is to create good communication between themselves and with their audience. They sing their dialogue in a style called *malat*, joking and teasing each other about infidelities, sometimes playfully arguing, but always making up and reasserting their love. They are the ideal older couple, very comfortable in their relationship, sometimes calling each other *dadong* (grandmother) and *kaki* (grandfather). If the audience is comprised mainly of children and young adults, the dialogue may be raucous and risqué. It will be more formal for dignitaries.

The couple dance about each other in low swoops and whirls, bouncing and weaving to the music. Jero Gde speaks in a slow-paced, sonorous voice interspersed with a laugh as deep as the sound of kettledrums, while Jero Luh converses with a shrill, nasal tone. If other puppets, usually those representing a prince and his consort, are included, the couple behave in a more refined manner, both physically and vocally, and their love scenes are laced with poetry.

Banjar Kaliunggu in Denpasar possesses the oldest Barong Landung in Bali and is one of the few temples to own more than two puppets. In addition to Jero Luh and Jero Gde (whom they call Ratu Ngurah Agung), there is a small, red-faced male named Mantri Anom and twin females called Putri. When the traditional story is dramatized, the five puppets are rotated to play the various roles. They perform the drama "The Story of Cupak Grantang," a popular one frequently presented in

other forms throughout the island. Besides enacting this drama of justice, the Barong Landung puppets of Banjar Kaliunggu represent philosophical concepts of balance basic to Bali Hinduism. Between them, they encompass the colors symbolic of the four cardinal directions and the gods who rule them: red represents the south and Batara Brahma, yellow the west and Batara Mahadewa, black the north and Batara Wisnu, and white the east and Batara Iswara. Likewise, the smaller puppets, Mantri Anom and the Putri, complement each other's natures: the male containing elements of heat, energy, and enthusiasm, tempered by the subtle charm and dreamy nature of the twins.

THE STORY OF KUNTI SERAYA

The story for this drama is an episode from the *Mahabharata* epic. Introducing the performance is a dance interlude that features either several of the Telek and Jauk masks, engaged in a sort of rivalry, or a comic sequence in which the Barong Ket dances solo and then plays with a performer wearing a monkey mask.

The servants of the Prime Minister to King Pandu in the Kingdom of Hastina discuss the situation in their country. A witch is causing death and destruction. They are unaware that this is part of a master plan by the God Siwa, who has decided he wishes to have his wife Durga, Goddess of Death and Queen of Witches, united with him in heaven. In order to do so, she must transform from her witch form and be purified.

The King's first wife, Kunti, enters, looking for her favorite, Sahadewa, son of the King's second wife, Madri. He is kind and obedient, and greets his stepmother. The witch Berawi (wearing the Cululuk mask from the Calonarang drama), who has been sent by Siwa, arrives unseen by all. Berawi puts a curse on Kunti, causing her to become angry and hateful toward Sahadewa, and she condemns him to death. The Prime Minister feels pity for Sahadewa, but he is bewitched by Berawi as well, and orders his servants to tie Sahadewa to a tree in the cemetery to be devoured by Durga.

Siwa (who might be wearing the Telek Muani mask) appears and rewards Sahadewa with invincibility. Durga, accompanied by her servants (including Serenggi), arrives to claim her offering. With relish she sinks her fangs into the young man's neck, only to be surprised by his invincibility. She tries again and then calls for her student, Kalika, to bring her a sword. She attempts to decapitate Sahadewa and is again repelled. Knowing that she has met her match, she also realizes that this is the person who can release her from her witch form. Sahadewa purifies Durga, and she is transformed to Dewi Giri Putri.

Durga's demon servants and the monkey mourn her passing, and Kalika bitterly denounces Sahadewa for destroying her mentor. A fight ensues when Kalika demands to be redeemed as well. Sahadewa refuses, because this would leave no one on earth to govern black magic. Kalika transforms herself into a wild boar, a Garuda bird, and finally a Rangda (wearing the red Rangda mask). Unable to conquer Kalika, Sahadewa calls upon his power in the form of Barong Ket. The Barong battles with Kalika, matching her blow for blow. His army then appears. Filled with rage at the sight of Kalika, they charge her, trying to stab her, but she causes their angry energy to be turned against them, and they fall into a violent trance, trying in vain to stab themselves. Kalika vanishes, and the Barong Ket and a priestess bring the army out of their trance with prayers and holy water. The conclusion reasserts the existence of both white magic and black magic.

BARONG KET

The most important and most common Barong is a supernatural creature, sometimes described as a combination of lion and tiger. He has the innocence and playful nature of a puppy, yet fights menacingly, snapping his great wooden teeth. As a representative of white magic, he can conquer, but not kill. The Barong Ket belongs to the family of demons, as evidenced by his bulging eyes, red complexion, and enlarged teeth. The zenith of his sorcery is evidenced in his sacred beard, which becomes holy if dipped in spring water. The hair of his great, shaggy body is made of *praksok* (the fiber of pandanas leaves), or *ijuk* (black palm fiber), or occasionally heron feathers, horsehair, or crow feathers. Peacock feathers, considered extremely powerful, may be used for trim. The face is framed by a large, elaborately tooled leather crown, called *sekar saji*, which is decorated and painted gold. It extends to a large rounded apparatus on the shoulders. Mirrors also embellish the leather work. Leather is used for a beautifully bowed tail, which trails a cluster of peacock feathers, several tiny bells that punctuate the performer's movements, and a small mirror. The mask is somewhat dwarfed by the size and opulence of the costume, the outer layer of which is connected to a wide-mesh rattan frame.

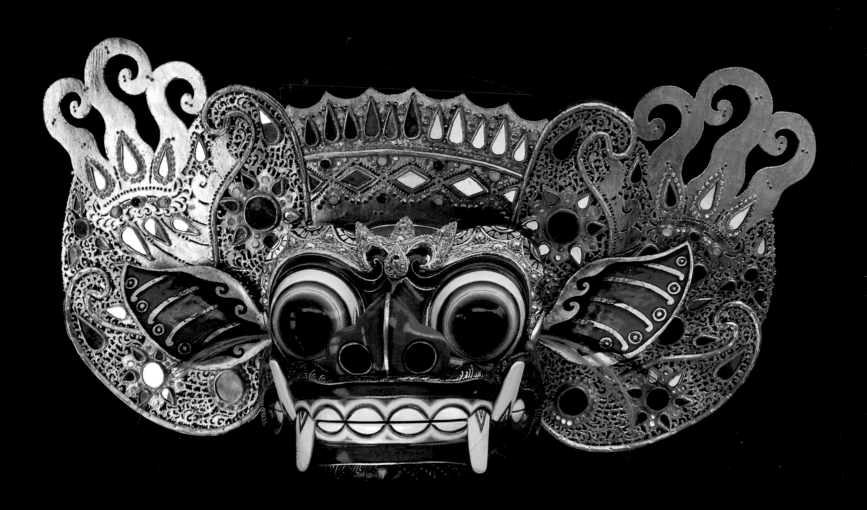

BARONG BANGKAL

Bangkal means "old boar" in Balinese. The boar, a common Barong, is connected with the holidays of Galungan and Kuningan, when it is part of a village procession. When the villagers see him, they feel the essence of the gods and goddesses protecting them. These two holidays are also occasions where pig meat is consumed, which also explains the appearance of the boar Barong. Depending on available funds, the bristles on the head of the mask are made of black sugar palm fiber or horsehair, and the costume of cotton or black-and-white velvet.

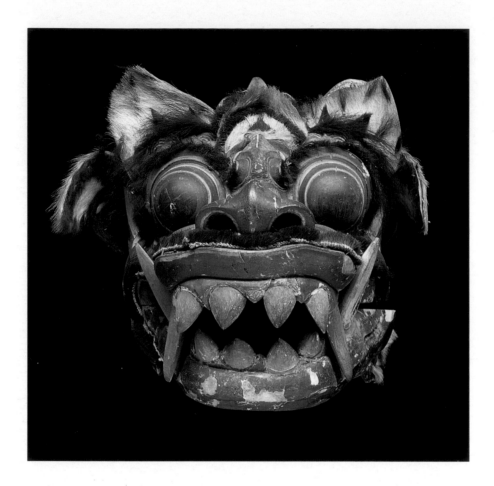

BARONG SINGHA

Representing a lion, this Barong is like Banaspati Raja, ruler of the forest. Barong Singha's image is associated with abundance and virility, and like the God Siwa, he is connected with sexual regener-ation in the form of rain, which promotes growth in the earth. His costume is usually made of velvet strips in two colors. *(Above)*

BARONG MACAN

This Barong resembles a tiger like those found on the Indonesian islands of Java and Sumatra. The tiger is seen as keeper of balance between the earthly world and the spiritual world. Appearing in many of the Tantri folk stories, Macan protects villages from the harmful influences of dead souls. His vivid orange and gold mask uses monkey pelts for the beard, mustache, and hair. Inscribed on his wooden tongue are the symbols of the Hindu Trinity. The costume is made of plain orange cotton fabric with painted stripes and includes a comical tail that is stuffed so tightly it is rigid. *(Right)*

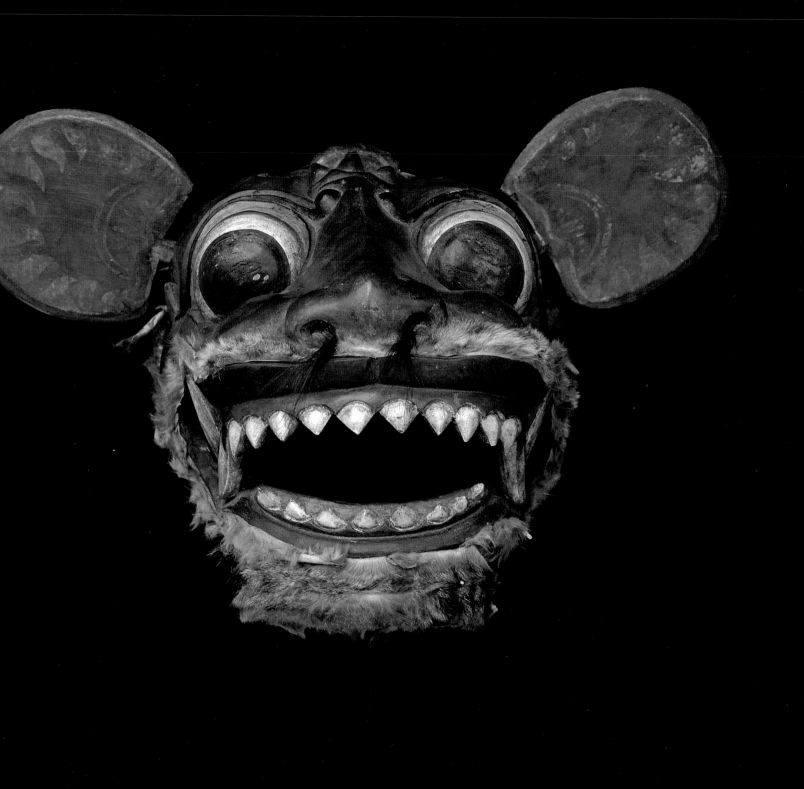

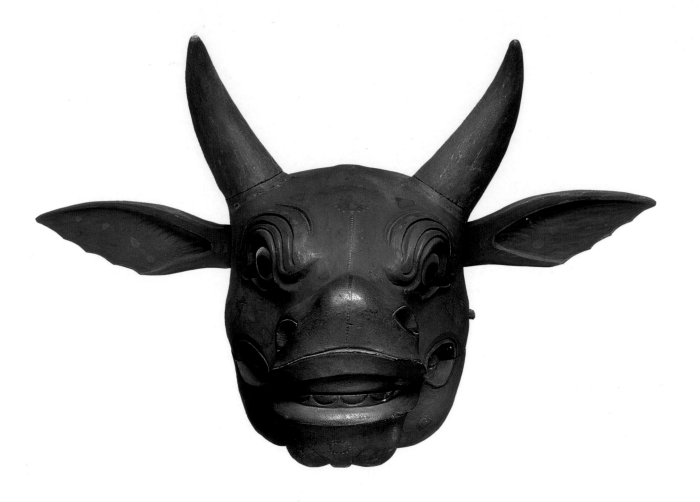

BARONG LEMBU

The bull Barong is somewhat obscure. It is one of the few Barong Lembu living in the village of Peliatan and at the *pura dalem* in Bangli. Other Barongs that are documented but have not been photographed are Barong Kedingkling (a monkey Barong, similar to Wayang Wong), Barong Kebo (buffalo), Barong Naga (dragon), Barong Djaran (horse), Barong Kambing (goat), and Barong Puuh (quail). *(Above)*

BARONG MANJANGAN

Like other Barongs, the deer is a protective spirit. The deer is an important symbol in Bali, and each Balinese family temple includes a shrine featuring a wooden deer's head with actual antlers, called Manjangan Sluang. It is dedicated to Empu Kuturan, the high priest from Java who created the forms for all Bali Hindu religious rituals. *(Right)*

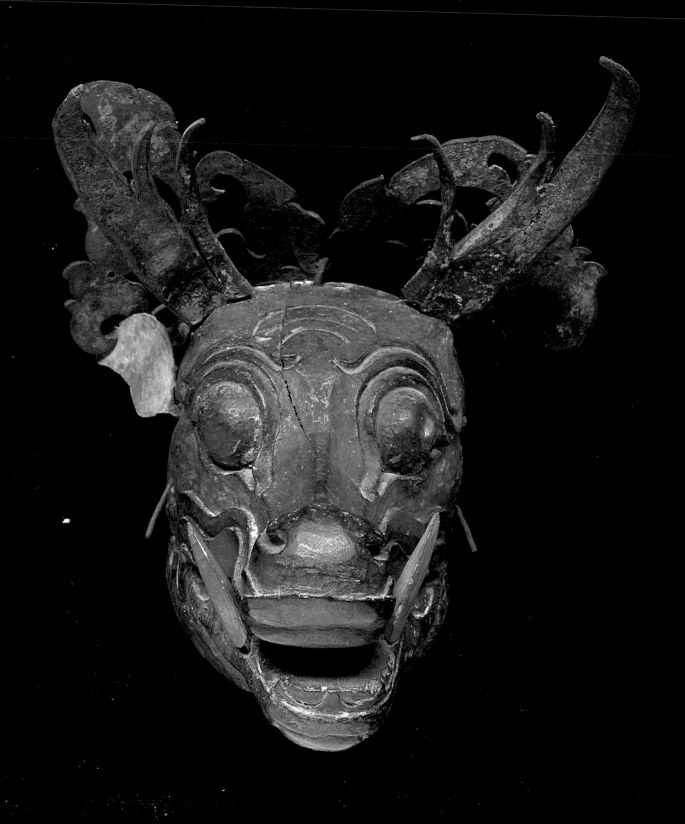

JERO GDE

Jero Gde looks like a grotesque black-faced monster but is actually a harmless clown. His appearance is based on that of a legendary incestuous demon from whom he inherited his curved tusks. His deep-set eyes, low forehead, and bushy white eyebrows give him a simian look, whereas the well-proportioned rounded nose and cheeks suggest that he has a jolly disposition. His large buck teeth set off by blood-red lips demonstrate his power. The darkness of his mask, body hair, and costume symbolize his Indian ancestry and also our subconscious instincts, passions, and desires. The graying shaggy hair and beard indicate that Jero Gde is actually an older man. His ears are adorned with decorations called *tindik*, a form of ancient jewelry from Hindu Java worn by men. His fangs give him the untamed, unbridled nature of one driven to pursue needs that are never satiated.

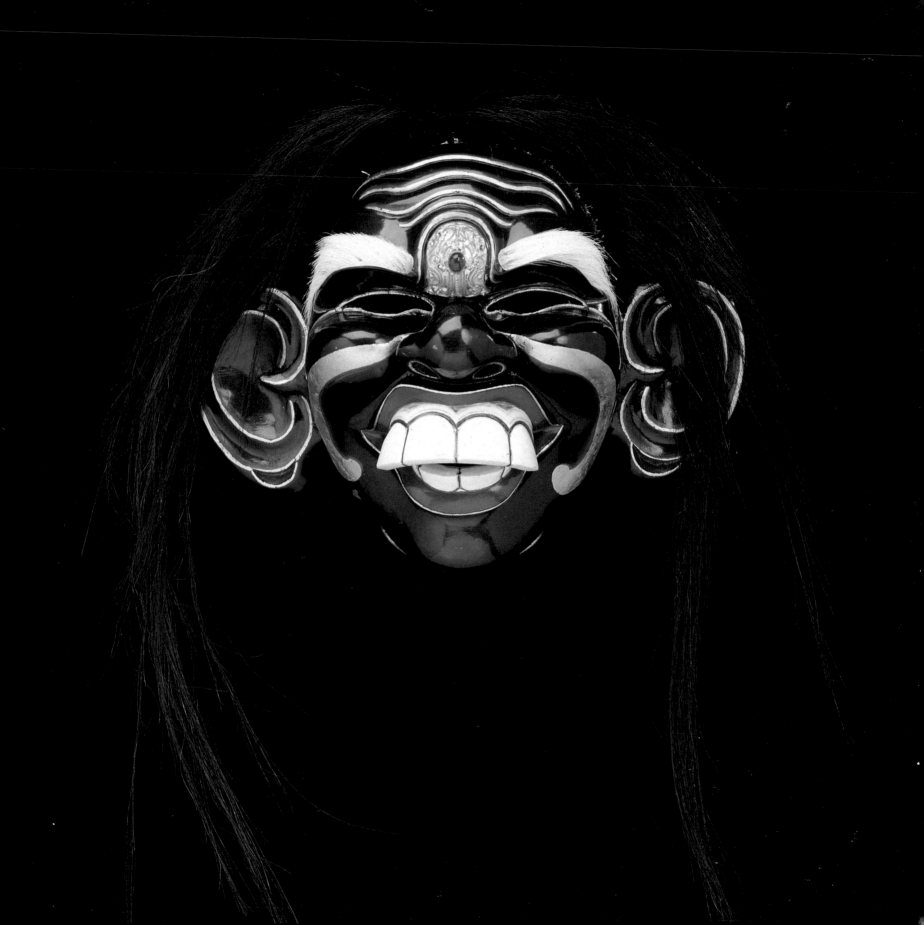

JERO LUH

The raucous woman from China may be aged but she is young at heart and therefore is a good match for her spirited husband, Jero Gde. Although she is equal to him in height and importance, she possesses more grace and elegance. Her white skin, a gift from her Chinese ancestors, is enhanced by her pale costume and gold forehead decoration, both of which originated in the Majapahit period of Hindu Java.

She has an extremely pointed chin and forehead, a dainty nose, and a mouth curved in a secretive smile. The deep wrinkles in her face, created from centuries of smiling, are highlighted in gold. The straight, dusty-colored hair of her headdress is pulled back into a prim bun at the nape of her neck. Sometimes, as in this mask, her eyes are carved so slanted that they are almost closed; in other masks, they are open wide in surprise. A crown of tooled leather, painted with gold leaf and decorated with flowers, adorns her head, and once-fashionable pluglike earrings distend her earlobes.

The peaceful nature of Jero Luh beams from small teeth hidden behind a contented smile, in contrast to the fierceness of her husband, and her forehead bulges with wisdom and knowledge. She controls her husband's passions and steers him in the right direction. The stature of both figures is a reminder of the vastness of our changing needs, exaggerated passions, and quest for knowledge. Jero Luh and Jero Gde rejoice in their multicultural relationship and encourage the audience to share their love in the coming year.

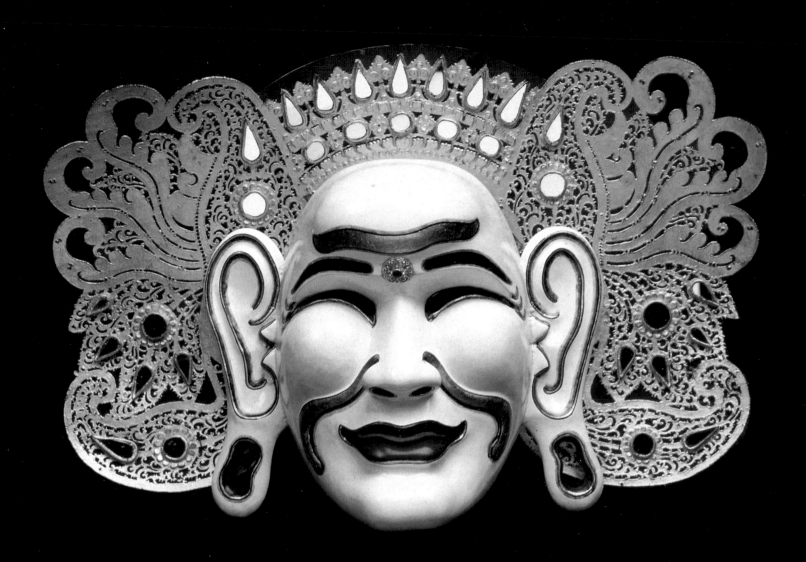

MATA GDE

Accompanied by a traditional costume, this mask is worn by a man playing a chief guardian-demon servant of Rangda in the drama enacting the story of Kunti Seraya. Mata Gde may be interpreted as humorous or frightening, depending on the interpretation of the story.

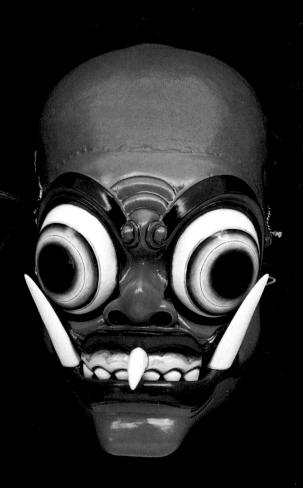

MONKEY

Monkeys are common animals in Bali. There are three sacred monkey forests, where protected simians dwell with their own temples, and wild monkeys are sometimes captured and made into pets. Balinese have many opportunities to observe monkeys, which gives the performer of the monkey role a chance to display acrobatic, mime, and comedy skills to an appreciative audience. The monkey is a favorite with Balinese of all ages, being clever, mischievous, and almost human in personality.

The monkey mask is one of the most expressive masks in Balinese drama. The widely carved eye holes allow the performer to convey a range of emotions. This expressiveness is further enhanced by the movable jaw, which can be manipulated with great effect. The costume—a grey-and-white-spotted jumpsuit—permits unrestrained movement. The performer wears gloves and is barefoot.

If the Barong Ket appears in a drama, he is the first character to enter. Parading through the performance area, he frightens away demons and consecrates the space. What follows is usually a comic interlude with a monkey, which teases the Barong, establishing a friendly relationship with him. Although both masks have movable jaws, the characters do not speak, and the plot is conveyed through mime, accompanied by gamelan music, punctuated by the clacking of the Barong's teeth.

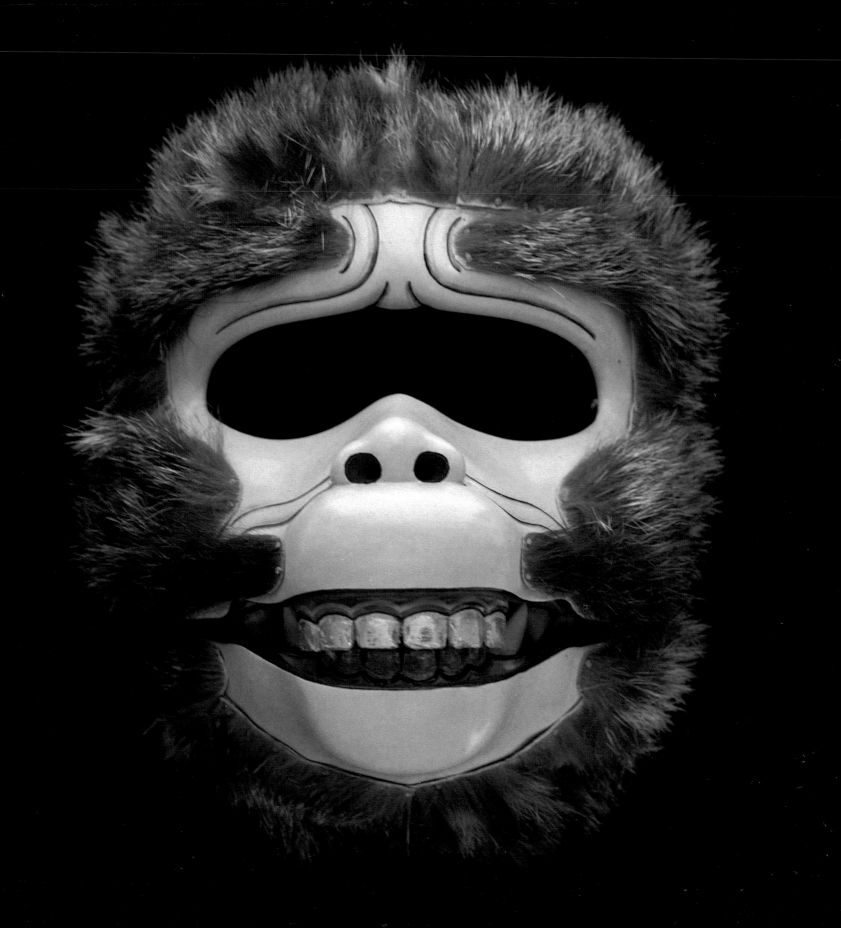

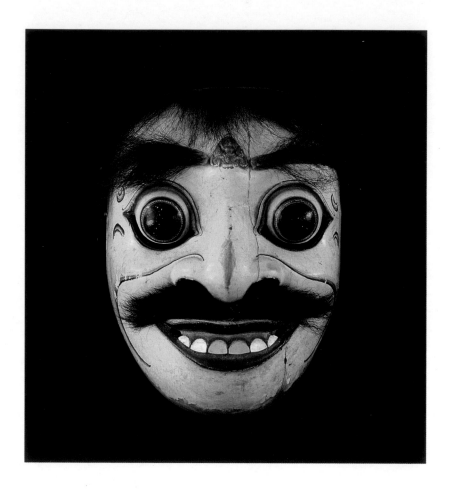

JAUK MANIS

The Jauk is a good example of the creation of a mask to represent a personality type rather than a specific character. Like the Telek, the Jauk is from the Sandaran performance, and the forces of the left, or low spirits, are strongly manifested in his nature. In a drama he represents menacing giants, demons in their destructive mode, or antagonist kings. The fierce face, with its rough, crude features, jocular leer, and buck teeth, combines the human and demonic. *(Above)*

JAUK KRAS

The Jauk can be of two types: the *manis*, or refined, sweet-faced Jauk, who moves in a slightly effeminate manner interspersed with comic gestures, or the *kras*, who is more aggressive. The woolly mustache of the Jauk Kras is made of goat hair, and the hair and brows of goat hide. *(Right)*

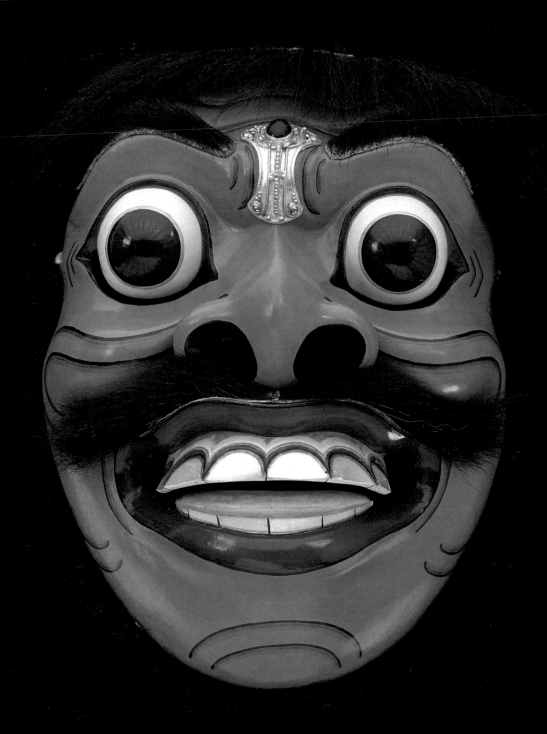

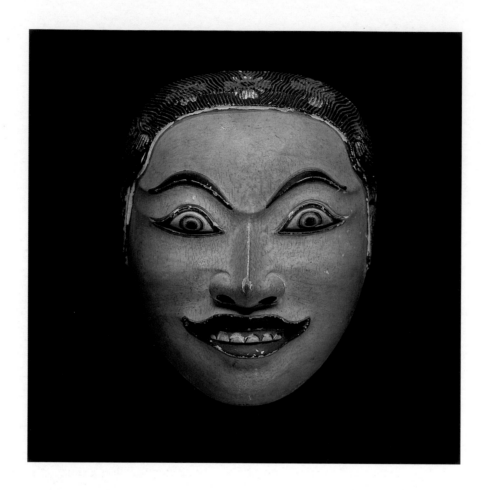

TELEK MUANI

TELEK LUH

The Telek masks, Telek Muani (male) and Telek Luh (female), make up a retinue for the Barong Ket, Lord of the Jungle and the most important mask in Bali. All three are related to the demon family. The sly smile and intense gaze of this mask hint at its demonic origins. The male Telek are usually played by five women, although roles were created in earlier times by men. A Dutch doctor who visited Bali in 1880 is the first to have made a written account of the existence of the Telek. Nowadays, however, the Telek is rare, and the Jauk appears frequently in a solo dance in tourist performances. If Jauk and Telek are included in the Barong drama, they usually appear in the Mandara Giri or Ksirarawa parts of the *Mahabharata* story. The Telek represents god figures, and the Jauk, Raksasa. The Barong represents the holy dragon Besuki. *(Above)*

The rarely performed female Telek, with its delicate upturned nose, sly eyes, and sweet smile, resembles the traditional Javanese female mask. She is a part of the Barong dance called Sandaran, where the Telek, Barong, and Jauk appear together. Telek represents the feminine, the *manis*, or refined, behavior, and is therefore a spiritual being or protagonist. Her subtlety, grace, and refinement balance the roughness of her counterpart, the Jauk Kras. The teeth are somewhat ominous, though the smile is intended to be pleasant. *(Right)*

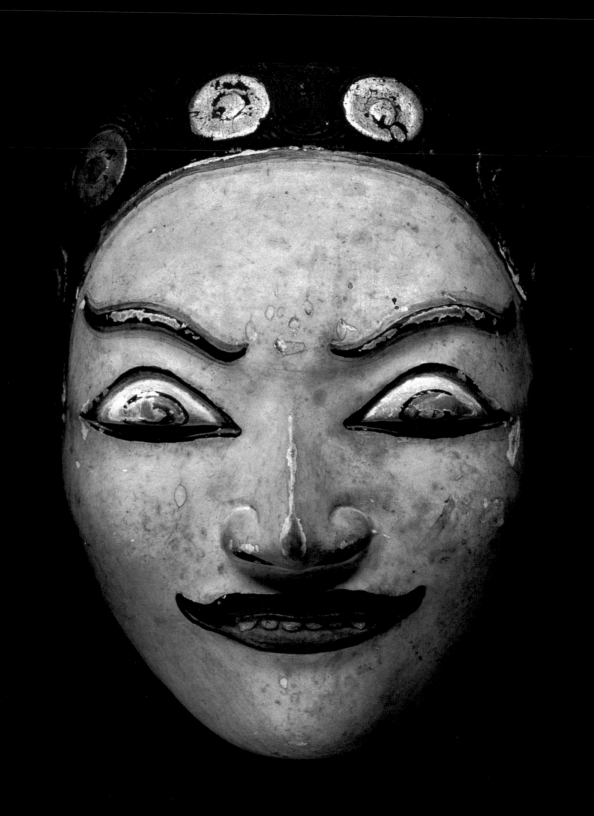

THE ART OF MASK CARVING

The mask carver—the *undagi tapel*—is a specialized craftsman who has likely come to his calling through heredity. Most of Bali's mask makers live in Mas or Singapadu, the villages of their ancestors, and before becoming a carver must experience a purification ceremony and understand the rituals connected with sacred masks. Only a few carvers make sacred Barong and Rangda masks, and a few create performance masks. The majority produce works for tourists.

Because the sacred Rangda mask is very important, it is carved only by consecrated individuals in a prescribed manner. Some villages have two Rangda masks, one kept in the temple of the dead, the other in the village temple. Both are carved from the living *kepuh-rangdu* or *pule* tree in a ceremony that asks permission of the tree's spirit to use the wood. The oldest Rangda mask in Bali is said to reside in Pacung village, although other Rangda masks have interesting histories and powerful reputations. Many facsimiles of Rangda exist for sale in Bali, which is not sacrilegious. The sacred aspect of the mask comes from its treatment by the carver, the wood that is used, the magic letters inscribed inside it, and the spirit power it receives in the *pasupati* or *ngerehin* ceremony.

Like the Rangda, the Barong mask commands great respect from the few Balinese communities that possess them. Almost every village in south Bali claims at least one Barong, but the masks are less common in northern areas. If the priest of a temple has a vision instructing the worshippers to acquire a Barong, the villagers will find the needed funds. Top-quality masks cost several hundred dollars to make, and the costume several thousand, quite a sum for poor villages to raise. If a temple is directed to secure a sacred Barong mask, the villagers must approach one of the few carvers on the island capable of creating it. Only carvers who are members of the high caste are allowed to initiate the carving of sacred Barongs, and the difficulty of forming the mask further limits the eligible.

As the carving process itself is sacred, the temple priest, carver, and villagers select propitious days to cut the wood and begin the carving process. Whereas a tourist Barong may take one to two months to complete, depending on the painting, creating a sacred Barong extends carefully and unhurriedly over four months.

The choice of a tree from which to secure the wood is also extremely important. Sacred trees include the *pule, waru taluh, kayu kepah, kayu jaran,* and especially the *kepuh-rangdu,* in which the spirit of Banaspati Raja's soul is said to reside. *Punyan pule* is used for common masks. Both *kepuh* and *pule* wood are strong but not thick, which facilitates the carving process, and are light in color, which makes them simple to paint. All of the trees are found in warm climates in Southeast Asia.

Chopping down a tree is dangerous. Instead, a small amount of wood is taken by a priest and the carver, accompanied by prayers and offerings that ask the permission of the spirit of the tree. Two offerings are made, one to the god of the place where the tree grows (usually a temple or a crossroad) and the second to the spirit of the tree. If the tree is especially *tenget,* or filled with divine natural energy, the process is perilous, particularly for the priest. In the case of secular masks, wood is sold to carvers by mountain dwellers.

Once the wood is cut, it is taken to the *pura* of the carver, where it will eventually reside, and during the carving process the carver works in that temple. The wood must be allowed to dry out for

several months, as green wood is said to endanger the health of the carver. If the wood is deemed sacred, it will be kept until a prescribed day.

The shape of the mask and all design details are made in accordance with the wishes of the villagers. Only traditional paints, made of organic materials, are used, and the prescribed painting procedure is long and complex. Two offerings take place when the carver begins work: one to Bhatara Surya, the Sun God, as witness of the work, and one to Taksu, the spirit of inspiration or "talent," asking a blessing for success. Holy water is sprinkled on the wood and the carver's instruments, and the carving process, the same for both sacred and tourist masks, begins.

The carver first shapes the raw wood with a hand axe, using quick, rough strokes. The outline of the face and its features starts to appear. The forms are further refined with flat and smooth chisels. The carver sits cross-legged, usually on a woven mat, steadying the wood with his feet, since both hands are required for carving. The most difficult aspect at this point is achieving symmetry.

Using a knife to create detail, the carver searches out obscure and stubborn areas, especially the eyes and nasal and labial folds. All the while, the carver intermittently stops to examine his work, comparing it with another mask or looking at it in a mirror. The back of the mask is cut out with a curved knife, and concave areas are shaped to accommodate the facial planes of the wearer. Eyes are carved out. If the mask is commissioned by a dancer, the performer comes for a fitting, especially for a mask that has a movable jaw controlled by the actor's facial muscles. If the mask is being made for a Westerner, more room is allowed for the nose. The surface of the mask is smoothed with a flat knife, then with different grades of sandpaper, a process that takes about four hours.

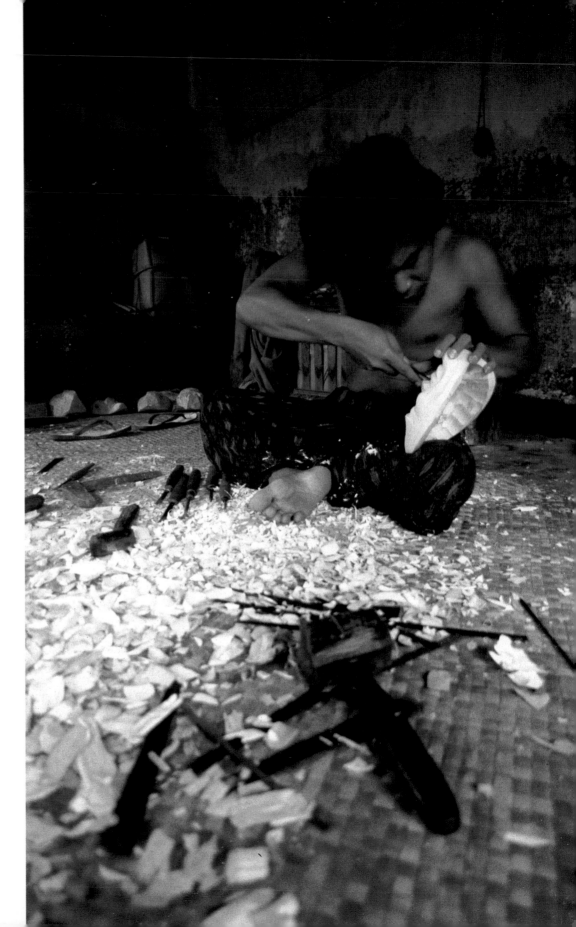

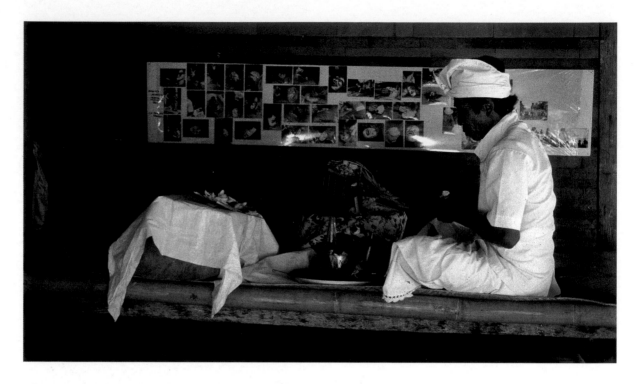

The next step, the process of painting, varies. For sacred masks, traditional paints, made from ground calcified pig jaw or deer bone, must be used as a base. Color comes from various sources: yellow from clay, black from carbon, gold from gold leaf, and red imported from China. Other colors are made by mixing these basic pigments. Secular masks are colored with imported commercial paints, and the painting process is much faster than for sacred masks. An unconsecrated mask can be created in about twenty-five hours, not counting preparation and drying time. Because natural paints spoil easily, a fresh batch needs to be made each day, and grinding the pigments is an ongoing process in the mask maker's home. The total number of coats varies. Masks made for tourists are usually painted thinly. A high-quality mask averages forty coats, and a sacred Barong, up to one hundred fifty layers of paint.

Trim is finally applied. Facial hair, most commonly from goatskin, is cut to shape and attached with knotted bamboo fasteners. Holes are punched next to the ears, and cotton string with a rubber strip made of old inner tubes secures the mask to the wearer.

If the mask is to be used in a religious ceremony, it must be purified to rid it of any uncleanliness that it accumulated in the process of creation. The Balinese endow particular parts of the body with spiritual symbolism. The head, as the container of the individual's spirit, is considered very high. Since masks are worn on the head, they share in this sacred status. Feet are felt to be low and unclean. During construction, masks are held by the carver's feet, and are stepped over and left on the ground, all considered demeaning to a sacred object. Consequently, the final purification process is more complex than the beginning one. The purification involves three steps: *prayascita* and *melaspas,* which purify the mask and costume from indignities suffered during the building process, and *ngatep,* the climax of the ritual for Barong and Rangda masks, which unites the mask with the body (costume) and enlivens the mask.

For sacred Barong and Rangda masks, an additional process, the most elaborate, must be held.

In the *pasupati* or *ngerehin* ceremony, the mask claims its spirit power and receives it in full view of the villagers, who must keep a safe distance. *Pasupati* ceremonies, held at night during the dark of the moon on a prescribed day, invite the deities to enter the mask. The ritual is performed twice, at six in the evening in the temple and at midnight in the cemetery. Three villagers who practice black and white magic serve as conduits for the spirit. Priests meditate in front of altars where the newly finished mask sits on a human skull. The spirit enters as a ball of flame that does not cast light or shadow.

If the ceremony is successful, around midnight when spiritual contact is made, the priest wears the mask and goes into trance, dancing or running about the graveyard, but is magically protected and unharmed. The graveyard is considered to be electrified by magic and very dangerous at this time. Those who are watching surround the Rangda or Barong. Capturing the priest, they make offerings to release him from the trance. Numerous Balinese have witnessed such a ceremony, after which the priest wraps the mask in a white cloth and places it in the temple. Now it belongs to the village and is their protector as long as rituals are followed to appease its spirit.

Care of the mask after it has been created is also dictated. Anyone considered taboo or unclean is not allowed to touch the mask. Offerings are dedicated to sacred masks on auspicious days, Kajeng Kliwon, the full moon, and the dark moon, and every time the mask is performed, especially on Tumpek Wayang, a significant day on the Balinese 210-day calendar, when all masks and shadow puppets are acknowledged with offerings.

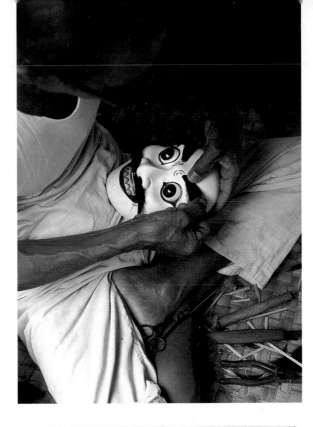

Wayan Tangguh adds facial hair, usually made of goat hide, with glue and pegs. A rubber strap holds the mask on the wearer's head.

A tree that produces a knot is considered "pregnant." A priest asks the spirit of the tree for permission to remove the knot in a religious ceremony before it is used to make a mask. Certain trees contain powerful spirits, such as this one in Singapadu, which is associated with the deaths of two priests from mysterious causes within a week after they removed one of the knots.

CARVER CREDITS

Cokorda Tubelen: Dewi Durga *(back cover)*

Cokorda Raka Tisnu: Cululuk *(95)*, Barong Ket *(105)*, Jero Gde *(113)*, Jero Luh *(115)*

Dewa Putu Bebes: Penasar Kelihan *(37)*, Penasar Cenikan *(36)*, Bondres Pasek Bendesa *(39)*, Bondres Kete *(41)*, Bungut Bues *(42)*, Nyoman Semariani *(45)*

Ida Bagus Anom: Raja Putri *(33)*

Ida Bagus Oka: Rama *(55)*

I Wayan Candra: Barong Macan *(109)*

I Wayan Tangguh: Patih Manis *(29)*, Topeng Tua *(31)*, Dalem *(33)*, Sidha Karya Putih *(46)*, Sidha Karya Selem *(47)*, Sita *(57)*, Laksmana *(59)*, Wibisana *(61)*, Hanuman *(67)*, Delem *(64)*, Sangut *(65)*, Subali/Sugriwa *(69)*, Jatayu *(71)*, Rawana *(73)*, Kumbakarna *(75)*, Indrajit *(74)*, Barong Bangkal *(107)*, Mata Gde *(117)*, Jauk Manis *(120)*, Jauk Kras *(121)*

LIST OF MASKS
WITH ALTERNATIVE NAMES

BIBLIOGRAPHY

Bandem, I Made. *Ensiklopedi Tari Bali*, Denpasar, Bali: Akademi Seni Tari Indonesia (ASTI), 1983.

Bandem, I Made, and I. Nyoman Rembang. *Perkembangan Topeng Bali Sebaga. Seni Pertunjukan*. Denpasar, Bali: Penggalian Pembinaan, Pengembangan Seni Klasik/Traditional dan Kesenian Baru Pemerintah Daeraah Tingkat I Bali, 1976.

Bandem, I Made, and Fredrik DeBoer. *Kaja and Klod, Balinese Dance in Transition*. Kuala Lumpur, Malaysia: Oxford University Press, 1981.

Bateson, Gregory, and Margaret Meade. *Balinese Character*. New York: Academy of Sciences, 1942.

Belo, Jane. *Bali: Barong and Rangda*. Seattle: University of Washington Press, 1953.

Belo, Jane. *Traditional Balinese Culture*. New York: Columbia University Press, 1970.

Belo, Jane. *Trance in Bali*. New York: Columbia University Press, 1960.

Covarrubias, Miguel. *Island of Bali*. Kuala Lumpur, Malaysia: Oxford University Press, 1932.

Daniel, Ana. *Bali Behind the Mask*. New York: Alfred A. Knopf, 1981.

DeBoer, Fredrik. "Pak Rejeg's Life in Art." *Drama Review* T82 (June 1979).

Eiseman, Fred B., Jr. *Bali: Sekala and Niskala*. (2 volumes) Berkeley–Singapore: Periplus Editions, 1989–1990.

Emigh, John. "Playing With the Past." *Drama Review* T82 (June 1979).

Geertz, Clifford. *Negara: The Theatre State in 19th Century Bali*. Princeton, New Jersey: Princeton University Press, 1980.

Haditjaroko, Sonardjo. *Ramayana, Indonesian Wayang Show*. Jakarta, Java: Pjambatan, 1981.

Hinzler, Hedi. *Bima Swarga in Balinese Wayang*. The Hague: Martinus Nijhoff, 1981.

Hooykaas, C. *Religion in Bali*. Leiden: E. J. Brill Press, 1973.

Jenkins, Ron. "Becoming a Clown in Bali." *Drama Review* T82 (June 1979).

Jenkins, Ronald. "Topeng: Balinese Dance Drama." *Performing Arts Journal* III, no. 2 (Fall 1978).

Jenkins, Ron. "Two-way Mirrors." *Parabola* 3, no. 3 (August 1981).

Kam, Garrett. "Wayang Wong in the Court of Yogayakarta: The Enduring Significance of Javanese Dance Drama." *Asian Theatre Journal* 4, no. 1 (Spring 1987).

Kakul, I Nyoman. "Jelantik Goes to Blambagan." *Drama Review* T82 (June 1979).

Kinsley, David. *Hindu Goddesses.* Berkeley: University of California Press, 1988.

Lommel, Andreas. *Masks, Their Meaning and Function*. New York: McGraw Hill, 1972.

Moerdowo, Raden. *Ceremonies in Bali*. Yogakarta, Java: Kanisius Press, 1973.

Moerdowo, Raden. *Reflections on Balinese Art and Culture*. Surabaya, Java: Perman Publishing, 1963.

Napier, David. *Masks, Transformation, and Paradox*. Berkeley: University of California Press, 1986.

Pandji, I Gusti. *Perkembangan Wayang Wong Sebagi Pertunjukan*. Denpasar, Bali: Proyek Pengembangan Sarana Wisata Budaya, 1974.

Ramseyer, Urs. *The Art and Culture of Bali.* New York: Oxford University Press, 1938.

Sorell, Walter. *The Other Face: The Mask in the Arts.* Indianapolis, Indiana: Bobs Merrill, 1973.

Spies, Walter, and Beryl DeZoete. *Dance and Drama in Bali.* London: Faber & Faber, 1983.

Stutterheim, W. F. *Indian Influences on Old Balinese Art.* London: The India Society, 1931.

Vickers, Adrian. *Bali, A Paradise Created.* Singapore: Periplus Editions,1989.

Vickers, Adrian. "In the Realm of the Senses: Images of the Court Music of Pre-Colonial Bali." *Imago Musicae.* Durham, North Carolina: Duke University Press, 1985.

Vidrovitch, Nina. "Introduction to the Mask." *Mime Journal* (Fall 1975).

Lontar Books in Balinese

Turunan Lontar: *Kaputusan Calonarang (Parembon)*
Druwen: Gedong Kirtya, Singaraja, Bali.
Nomor : IIIc. 1407/20
Antuk: I Kt. Mangku Ngarsa (translator)

Turunan Lontar: *Calonarang*
Druwen: Gedong Kitya, Singaraja, Bali.
Nomor: IV d. 1047/11
Katurun Antuk: I Kt. Mangku Ngarsa (translator)